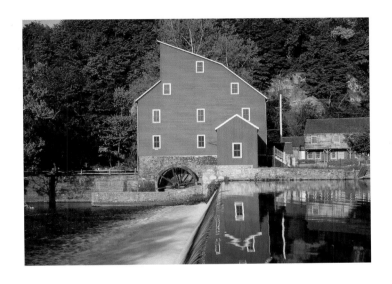

NEW JERSEY

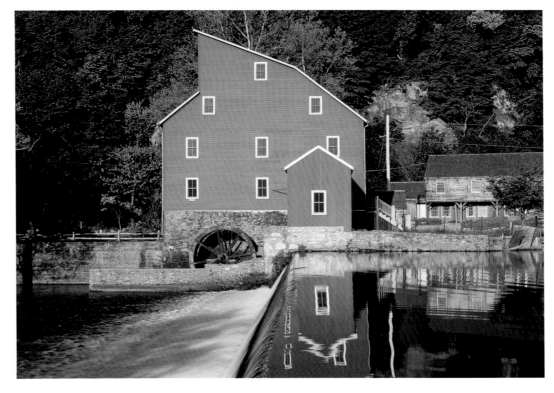

whitecap

Text by Tanya Lloyd Kyi
Edited by Elaine Jones
Photo editing by Tanya Lloyd Kyi
Proofread by Lisa Collins
Cover and interior design by Steve Penner
Cover and interior layout by Jacqui Thomas

Printed and bound in Canada by Friesens.

National Library of Canada Cataloguing in Publication Data

Kyi, Tanya Lloyd, 1973–
	New Jersey
(hardcover)—
	ISBN 1-55285-327-6
	ISBN 978-1-55285-327-6

	1. New Jersey—Pictorial works. I. Title. II. Series: Kyi, Tanya Lloyd, 1973-
America series.
E135K94 200266 1999974.9'044'022266 1999C2002-910076-3

The publisher acknowledges the support of the Canada Council and the Cultural
Services Branch of the Government of British Columbia in making this publication
possible. We acknowledge the financial support of the Government of Canada through
the Book Publishing Industry Development Program for our publishing activities.

*For more information on the Canada Series and other titles by Whitecap Books,
please visit our website at www.whitecap.ca.*

Imagine you're a soldier in the Continental Army. It's the winter of 1776, at the height of the American Revolution. British forces control most of New Jersey. The state's fledgling legislature has fled and, just across the river, New York City is firmly under British control. Your hope rests in a Virginian farmer who commanded British troops two decades ago—George Washington.

For long weeks it is quiet. Washington spends hours closeted with other leaders and strategists. Finally, on Christmas Day, your troops move. At Trenton, you surprise and conquer a force of hired German mercenaries. Within days, your commander has hired Pennsylvania militiamen, and with these reinforcements, you attack again. The battle at Princeton is longer but, by early January, New Jersey is once more American territory.

Today, this state is the most densely populated in America, with more urban area than any state except California. Yet reminders of the past abound. It's still possible to tour some of Washington's command posts and learn of the key turning points in the Revolution. The State Capitol in Trenton serves as a reminder of what the soldiers fought to protect.

Of course, New Jersey is not all about battles. Along the Jersey Shore, Victorian homes overlook the water, reminders of the nineteenth-century vacationers who flocked here from Philadelphia and New York. In the interior, ghost towns are remnants from the days when vast fortunes were forged from the ironworks.

Some of the nation's most magnificent natural areas also wait to be explored. On the western border, Delaware Water Gap National Recreation Area preserves 70,000 acres. Brigantine National Wildlife Refuge shelters rare species along the Atlantic coast, while Wharton State Forest encompasses the wilderness and wetlands of the central state.

New Jersey is one of the oldest states—one of the first to be settled and to declare independence. Much of this land is steeped in that history, from ancient sites of the Lenape people who hunted and fished here centuries ago to the grist mills and abandoned refineries. Yet for residents or visitors traveling the state, there are still countless fascinating places waiting to be discovered anew.

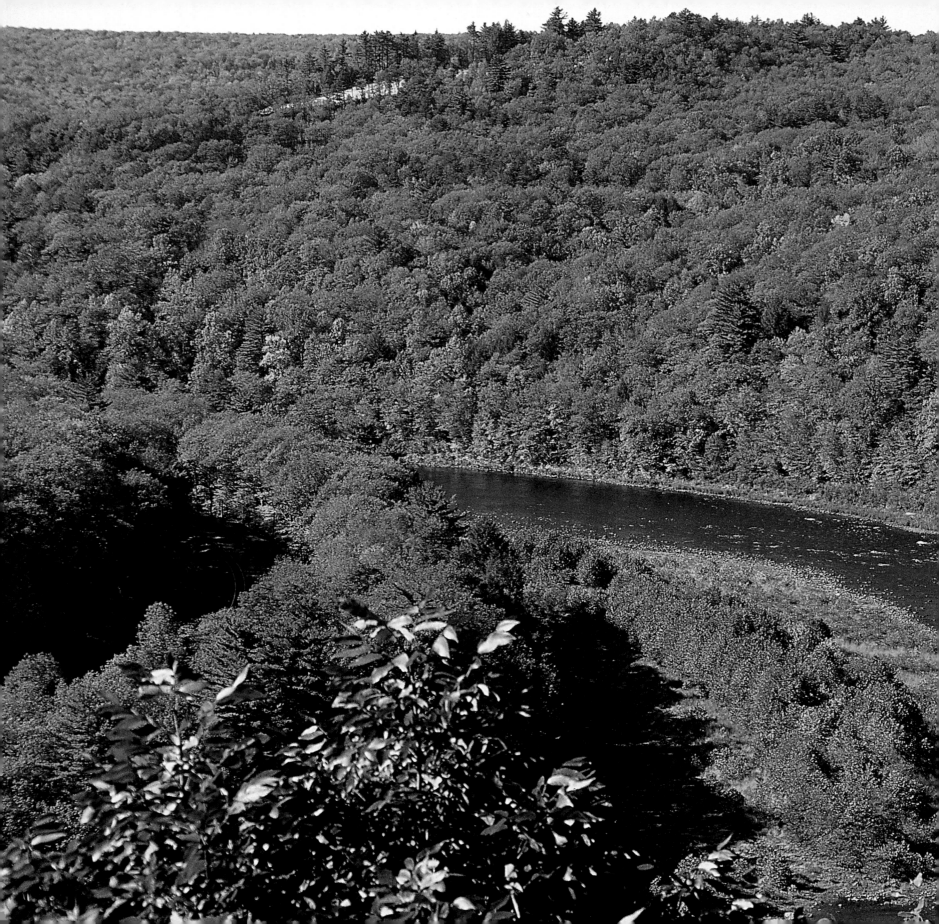

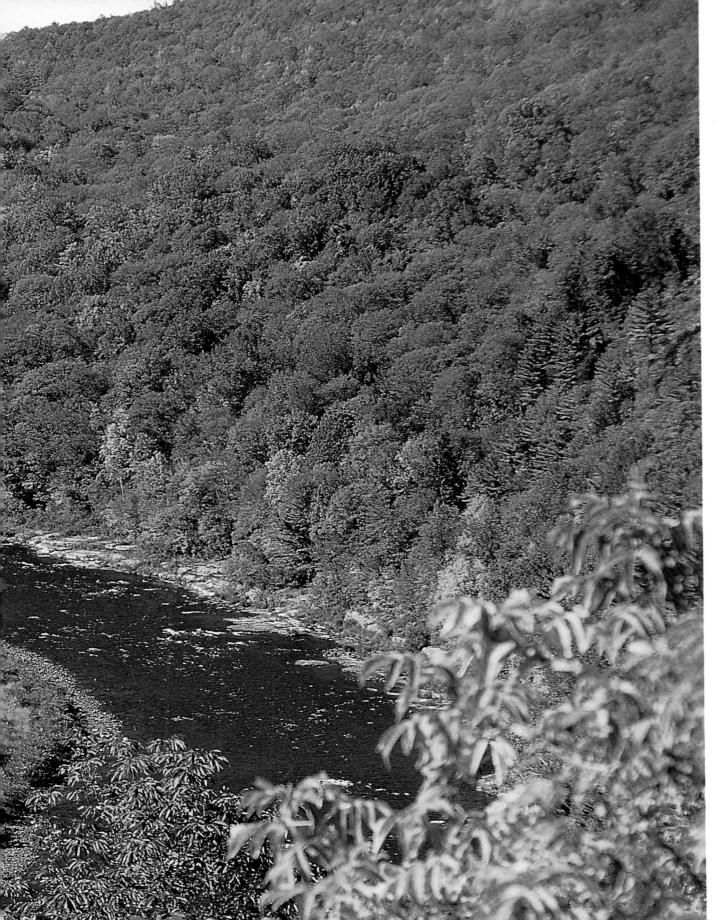

The Delaware River system drains less than half a percent of America's land mass, yet the watershed provides 20 million people with fresh water—almost 10 percent of the nation's population. New York City, Philadelphia, and much of New Jersey draw their water from the river.

Delaware Water Gap National Recreation Area encompasses 70,000 acres of New Jersey and Pennsylvania, tracing the Delaware River through the Appalachian Mountains. Under public pressure, the government denied a controversial dam proposal in the 1990s. This is now one of the largest undammed rivers in America.

Hiking trails in Delaware Water Gap National Recreation Area follow the paths of tiny tributaries as they cascade over the rocks of the Appalachian wilderness. Canoeing, tubing, rafting, fishing, and cycling are also popular within the park.

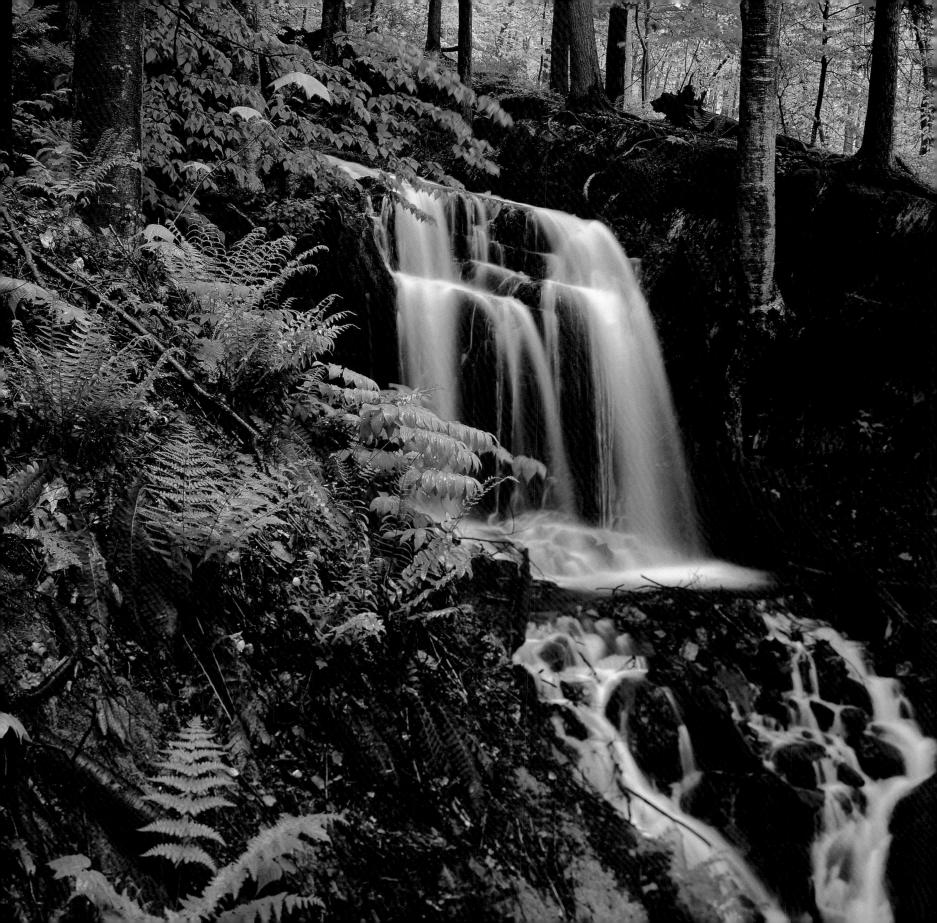

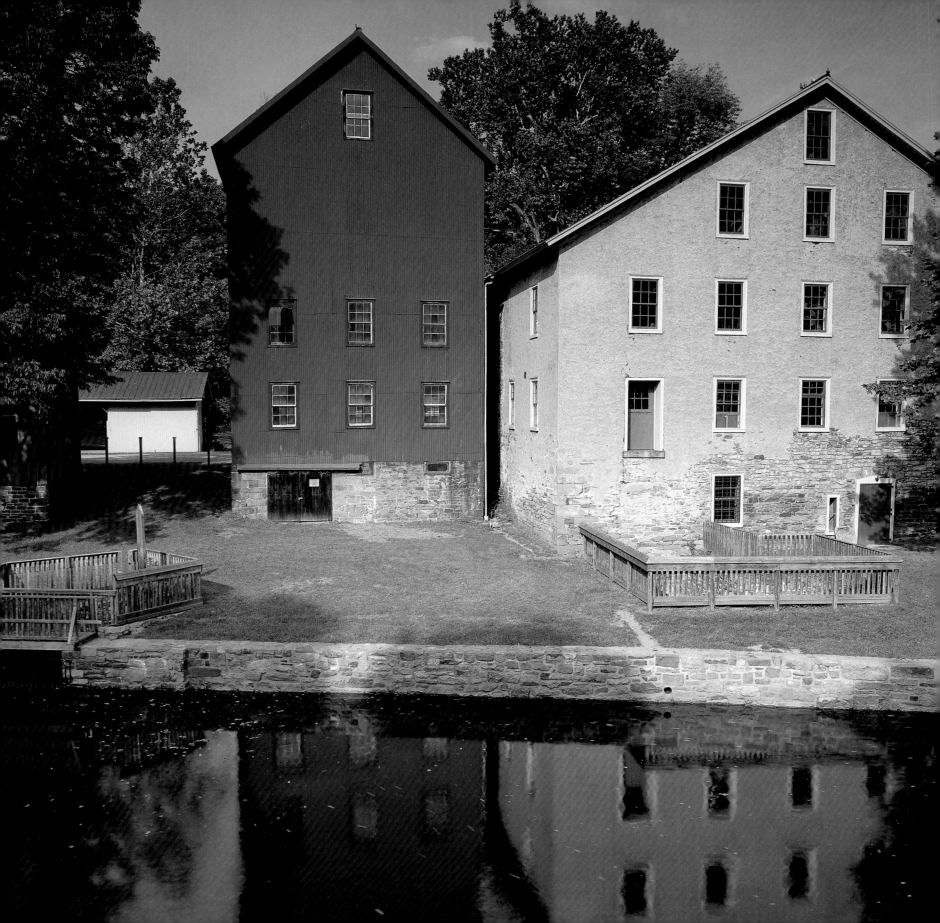

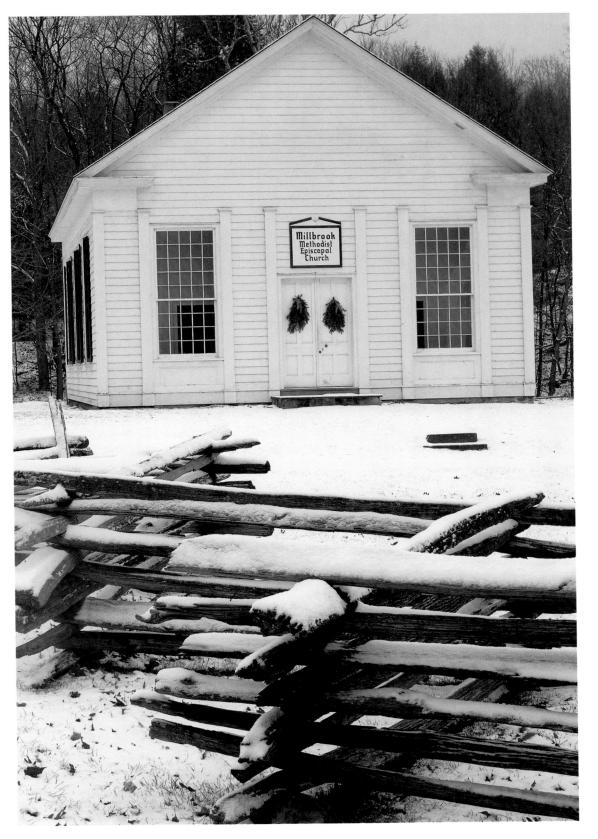

This picturesque church is preserved as part of Millbrook Village in Delaware Water Gap National Recreation Area, where a nineteenth-century settlement has been brought back to life. Visitors are likely to find costumed staff nearby, browsing at the general store, working at the grist mill, or chatting in front of a restored family home.

FACING PAGE—
Tracing more than 50 miles of serene water, Delaware and Raritan Canal State Park is the ideal place for a quiet canoe trip. Sights along the way, from wooden bridges and bridge tenders' cottages to historic locks and cobblestone walls, are reminders of the early 1800s, when this was part of a vital shipping route.

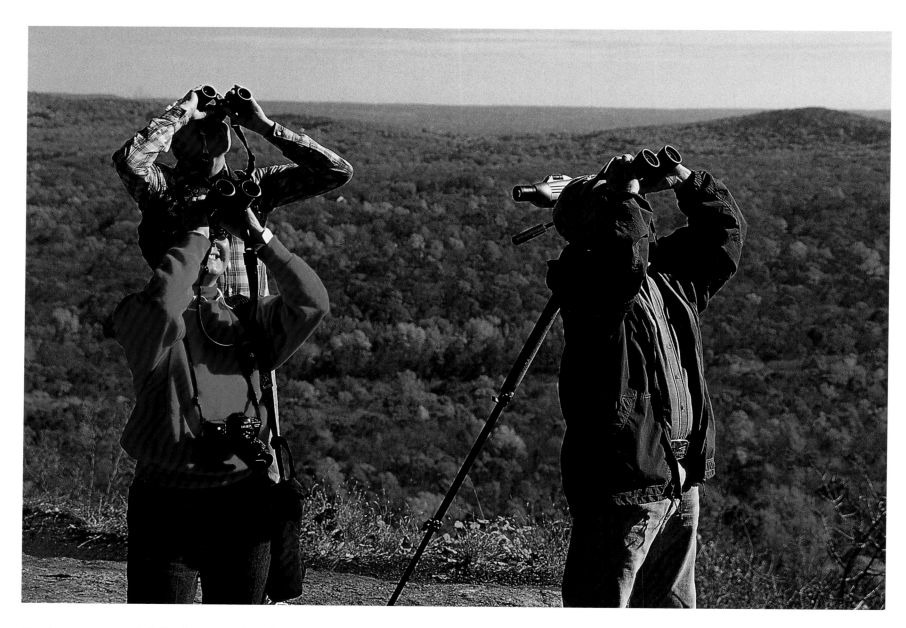

Each spring and fall, thousands of hawks migrate through New Jersey. Volunteers with the Hawk Migration Association of North America attempt to track and count the birds, scanning the skies from their post in Wildcat Ridge Wildlife Management Area.

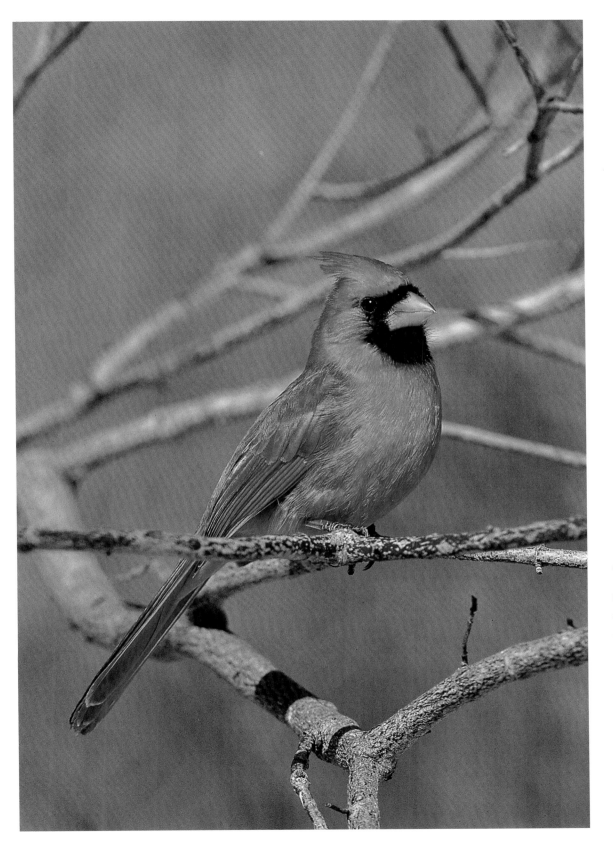

The bright red plumage of a male northern cardinal makes it easy to spot in the meadows and underbrush of rural New Jersey. These birds, which live in the eastern U.S. year-round, mate for life.

The Appalachian Trail winds through Stokes State Forest on its 2,168-mile route from Maine to Georgia. Opened to hikers in 1937, the trail is primarily maintained by volunteers, who donate 175,000 hours each year to the task.

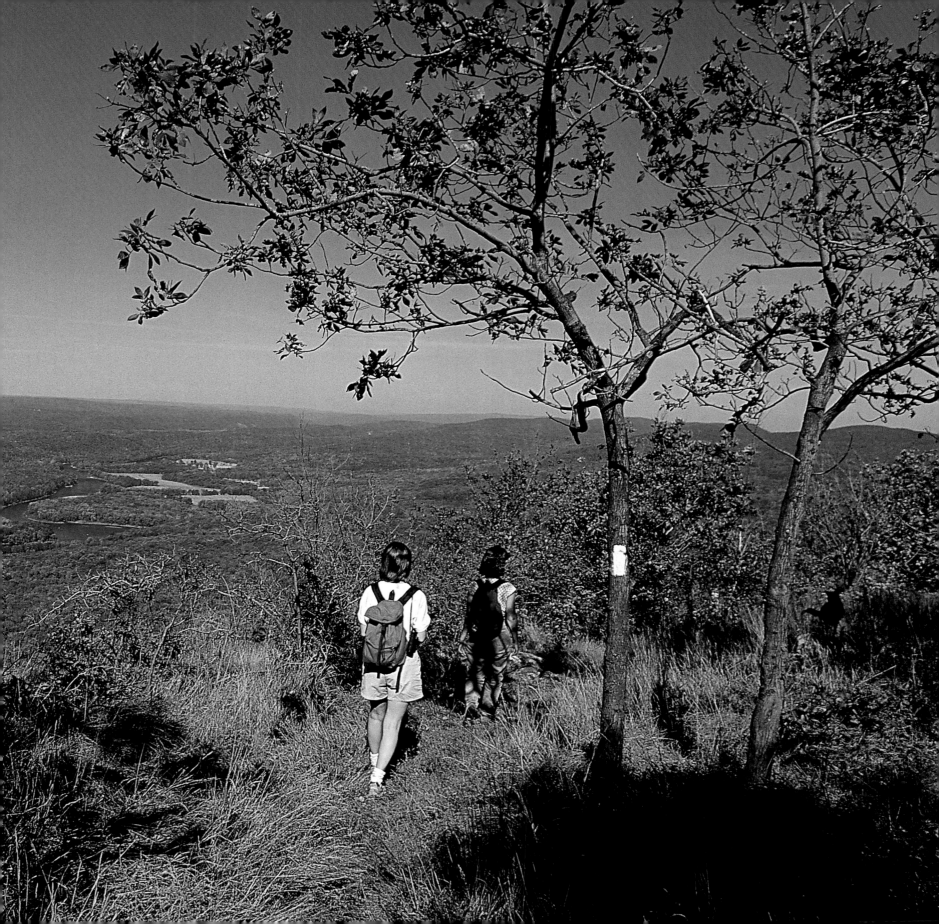

In High Point State Park in the Kittatinny Mountains, a 220-foot obelisk—built to honor the state's war heroes—crowns a 1,803-foot summit. Colonel Anthony R. Kuser and Susie Dryden Kuser donated the land for the preserve in 1923.

FACING PAGE—
Early loggers had stripped these slopes bare by the mid-1800s. Now, protected by 15,482-acre Stokes State Forest, the mountain laurels, pitch pines, and scrub oaks native to the region flourish once more. Picnic areas and campgrounds make the forest a favorite for family vacations.

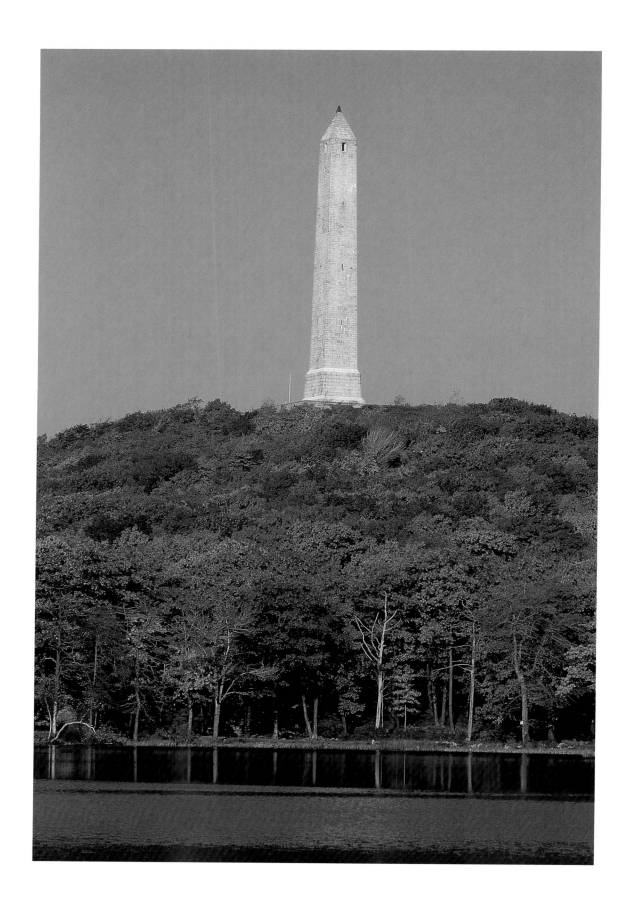

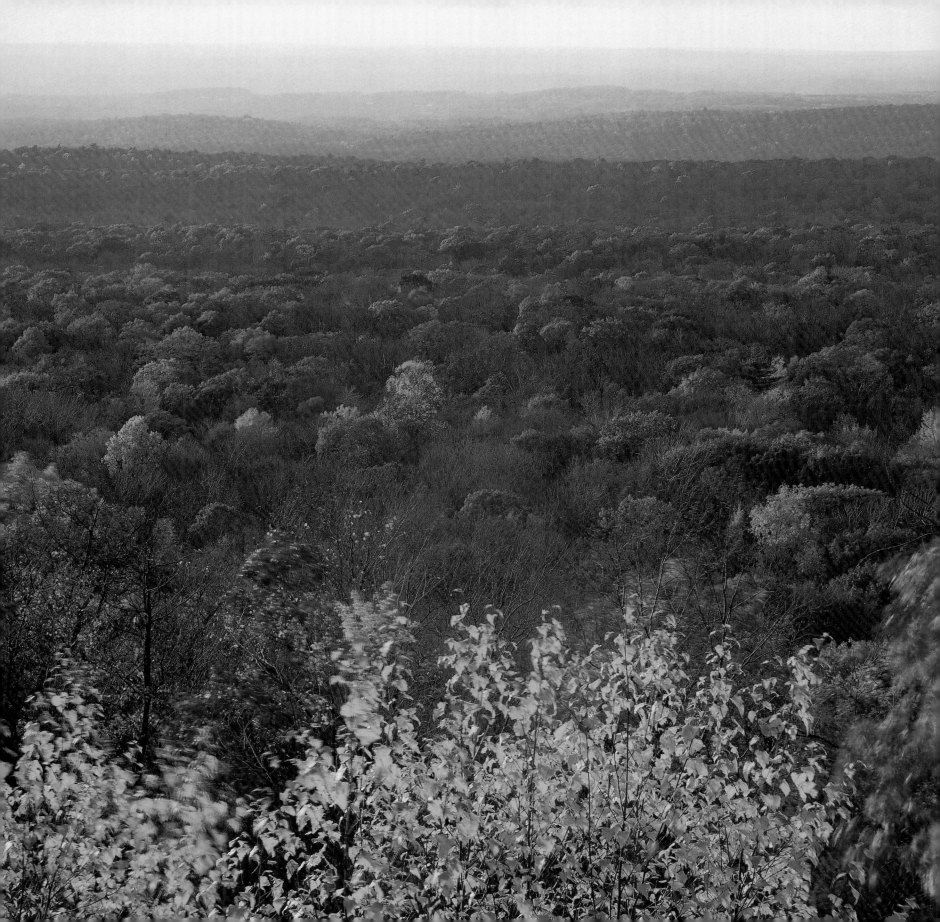

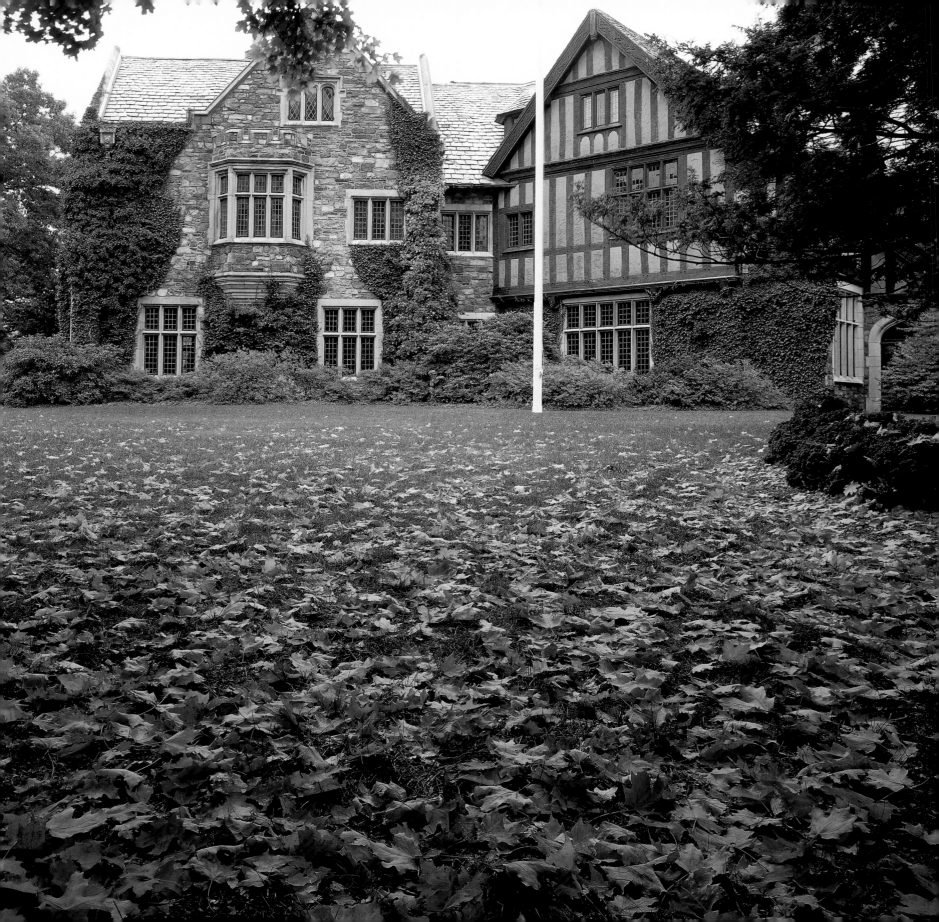

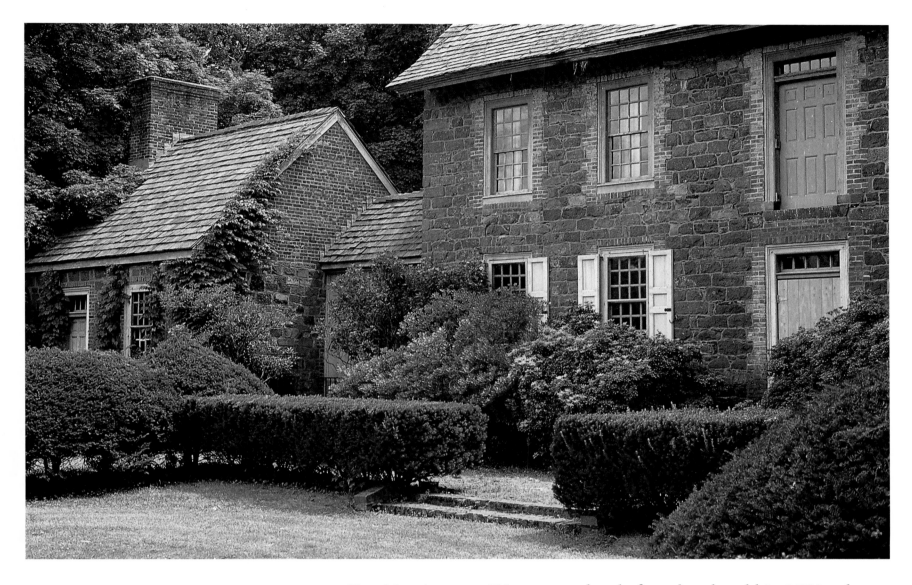

Dey Mansion near Wayne was already four decades old in 1780, when Colonel Theunis Dey invited George Washington to use the home as his headquarters. Here, the leaders of the American Revolution laid their plans for the Yorktown Campaign and the defeat of Charles Cornwallis.

From the mid-1700s to the late 1800s, the area that is now Ringwood State Park supplied the colonies of the New World with iron. Stately Ringwood Manor was home to the many men who managed the local forges and furnaces. It is now open to the public.

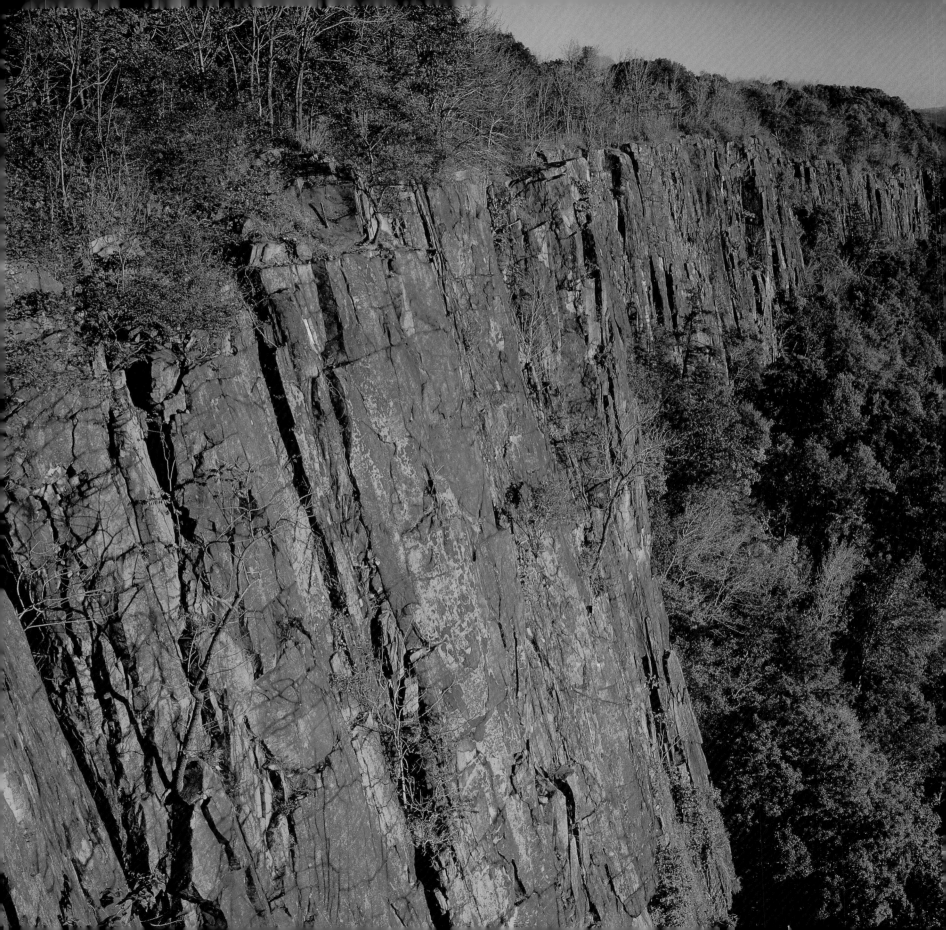

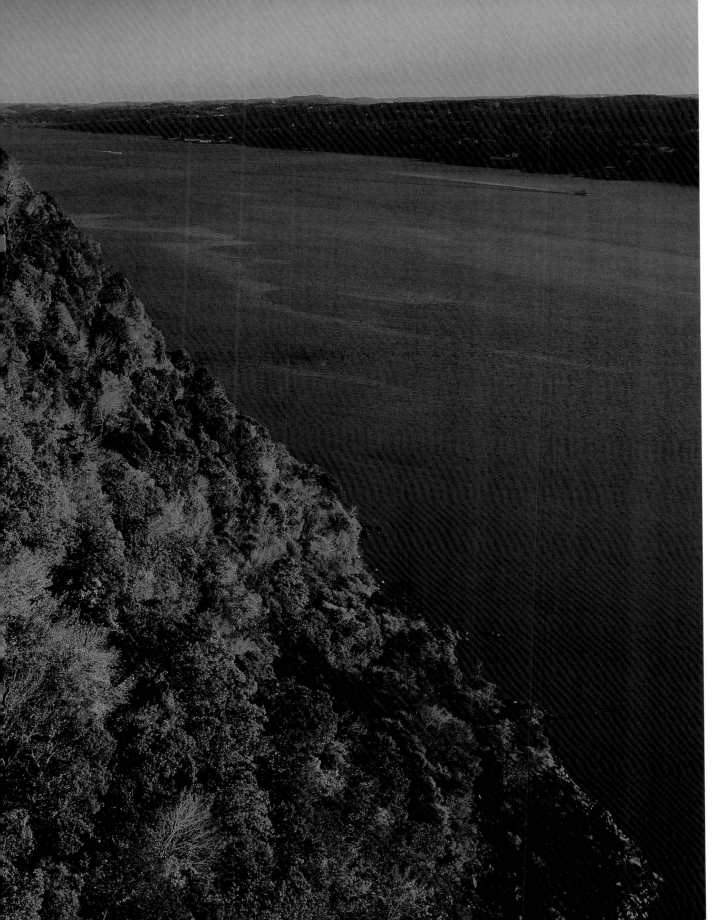

The Palisades
Interstate Parkway
traces the western
shore of the Hudson
River, offering mag-
nificent vistas of the
waterway and the
skyline of Manhattan
beyond. Thanks
to the Rockefeller
family and other early-
twentieth-century
philanthropists, much
of the land along the
parkway is protected.

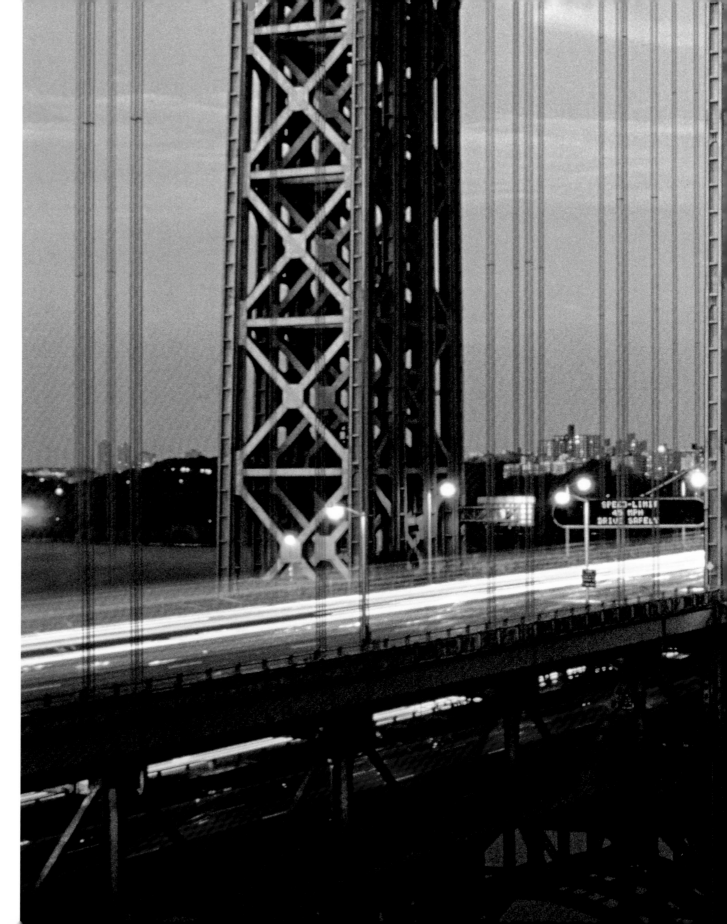

One of the world's busiest bridges, the two-level George Washington Bridge stretches 4,760 feet across the Hudson River between Manhattan and Fort Lee, New Jersey. The upper level opened to traffic in 1931, and in 1962 the bridge's lower level opened, increasing capacity by 75 percent to make the structure the world's only 14-lane suspension bridge. 108 million vehicles cross the bridge each year.

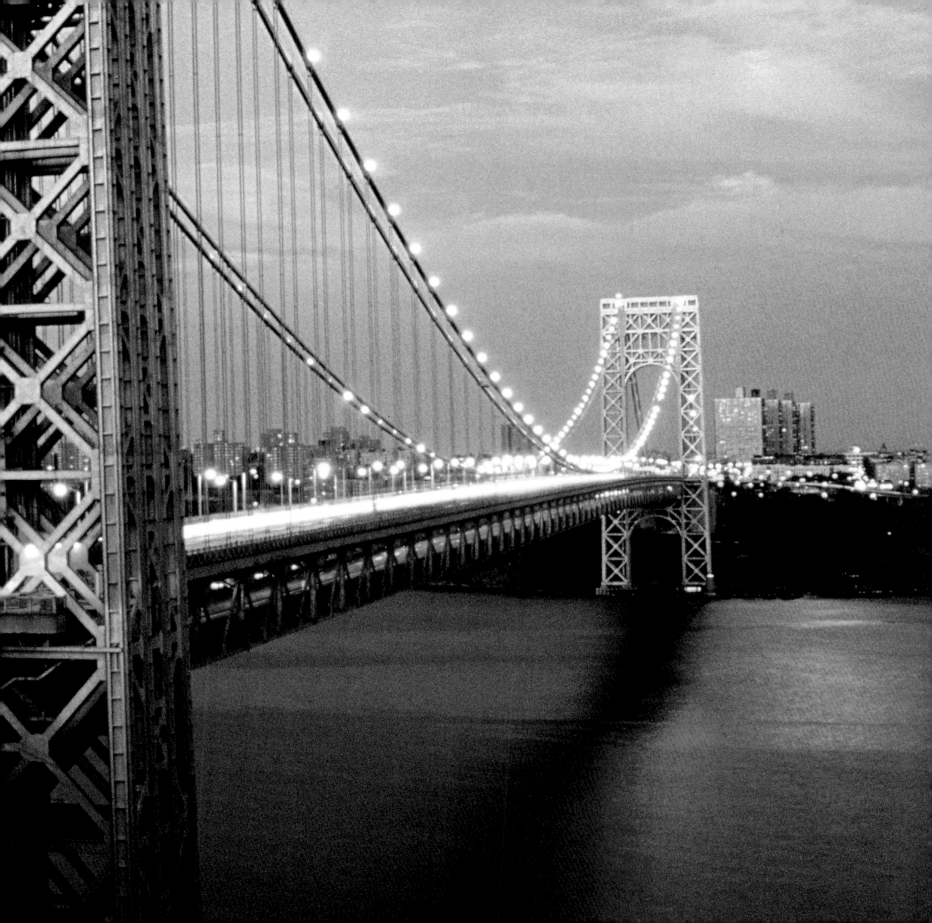

The city of Paterson in northeast New Jersey is named for state governor William Paterson, who signed his name to the Declaration of Independence. The power provided by nearby waterfalls made this a center for industry in the early 1800s. A century later, Thomas Edison's Electric Company harnessed the falls to provide the local manufacturers with electricity.

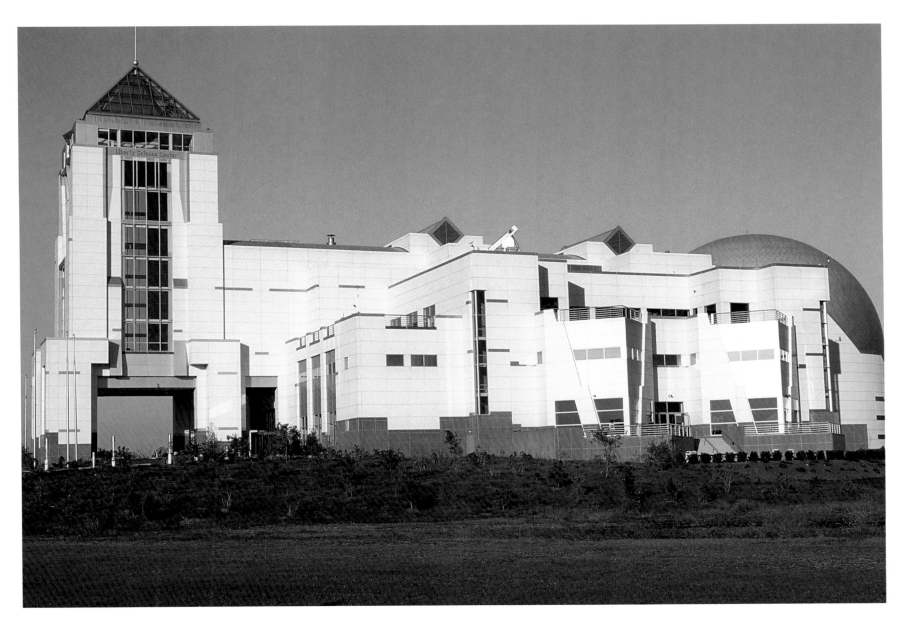

From virtual reality games that stimulate every nerve ending to a 100-foot-long Touch Tunnel, where visitors must feel their way through the darkness, Liberty Science Center houses hundreds of interactive displays. Three floors lead children and adults through the realms of invention, health, and the environment.

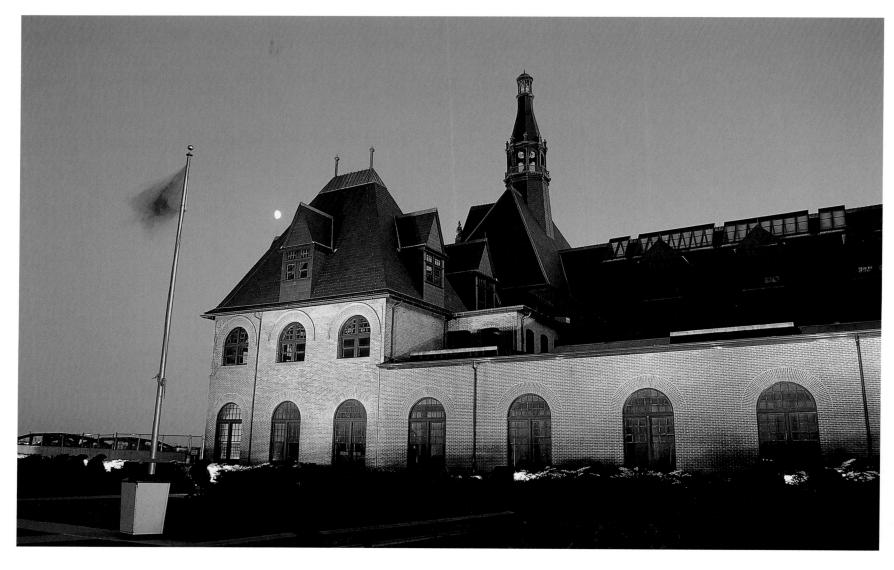

Although it operated until the 1970s, the Central Railroad of New Jersey was most successful in the 1800s, when it carried coal and passengers (including immigrants who arrived via Ellis Island) through New Jersey and Pennsylvania. The railway station stands at the north end of Liberty Park.

Ferries from Liberty State Park take sightseers to Ellis Island, where immigration officials inspected 12 million new arrivals to the country between 1892 and 1954. It is estimated that 40 percent of Americans can trace their ancestry to an immigrant who arrived via Ellis Island.

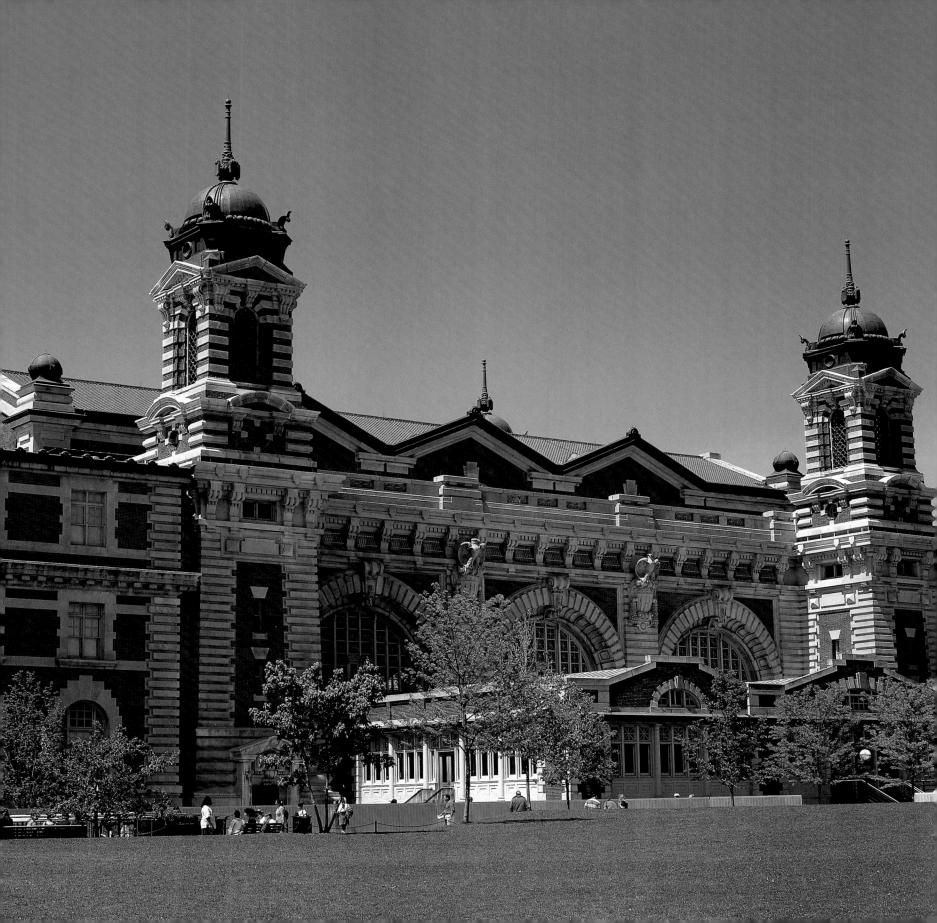

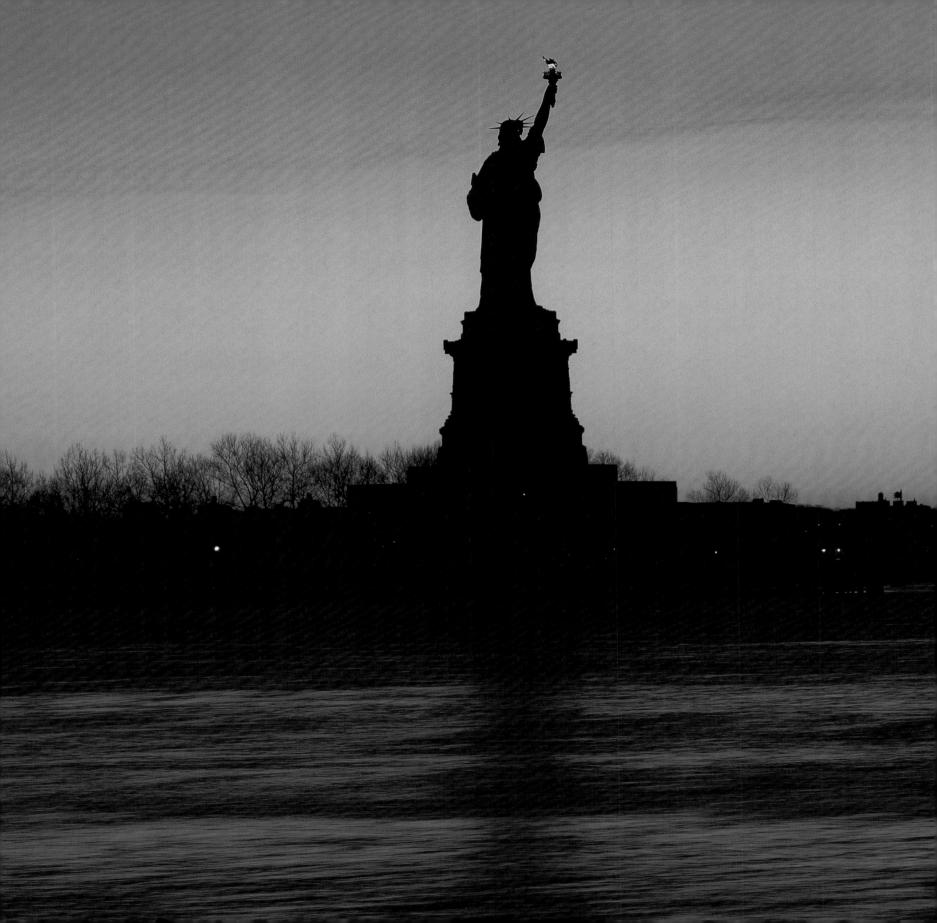

A waterfront promenade in Liberty State Park provides visitors with an up-close look at the Statue of Liberty in the New York Harbor. Dedicated in 1886, the monument was presented to the American people by the people of France as an enduring symbol of freedom and democracy.

Verona Park offers a pleasant escape for both Verona residents and visitors from Newark, just a short drive away. The park embraces 54 acres, including a lake, a boathouse, a gazebo, tennis courts, sports fields, and a playground.

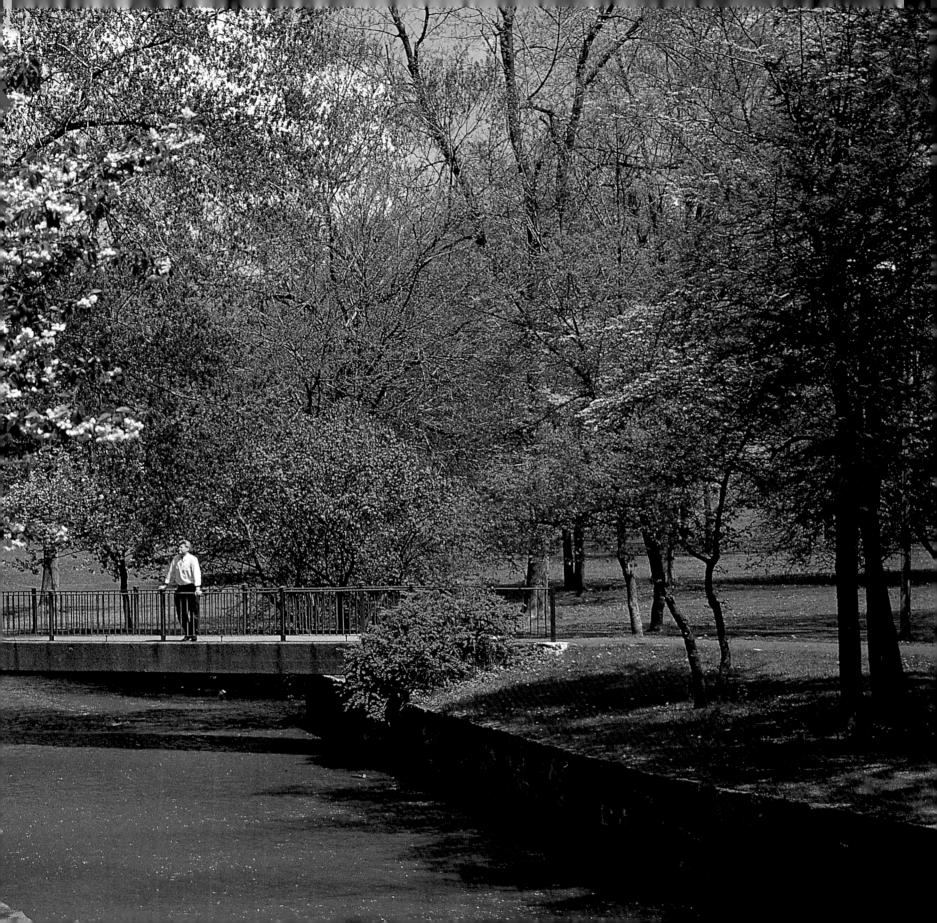

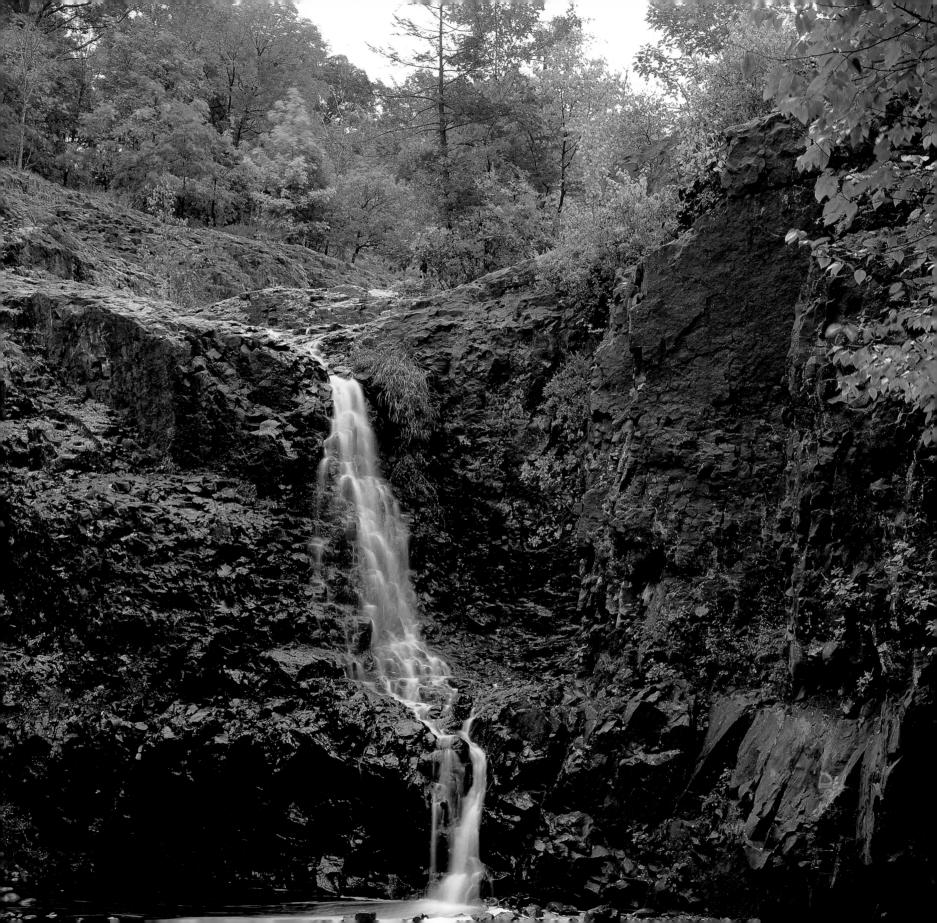

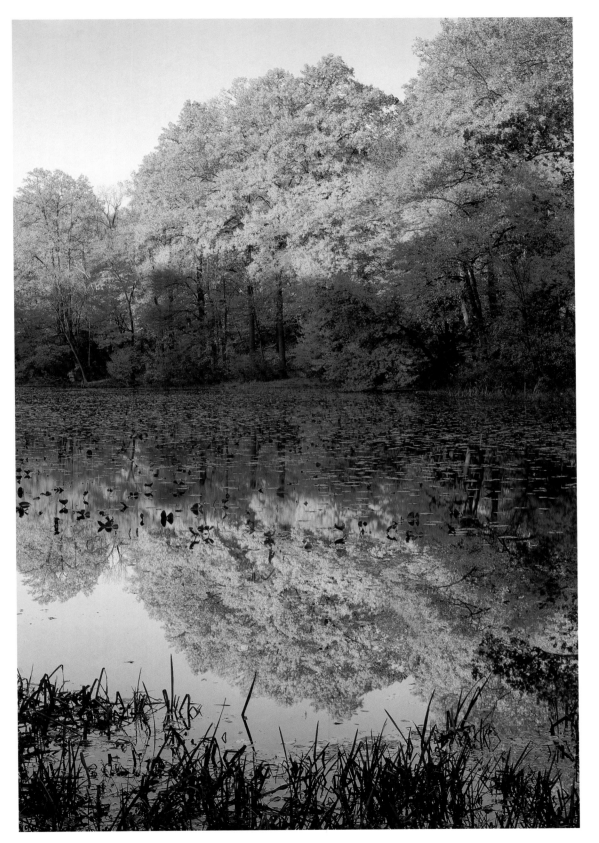

Watchung means "high hills" in the language of the Lenape native people who once made this region their home. The 2,000-acre Watchung Reservation includes woodland hiking trails, the historic ghost town of Feltville, and a Trailside Museum where visitors can see endangered poisonous snakes, learn about pond life, or observe honey bees.

FACING PAGE—
Like Verona Park, South Mountain Reservation in the Watchung Mountains was designed by John Charles Olmsted and Frederick Law Olmsted, Jr., the stepson and son of the legendary landscape architect who created New York City's Central Park.

Part of the estate of geologist Leonard J. Buck, this 33-acre valley was donated by his widow to the Somerset County Park Commission in 1976. The grounds include wildflower meadows and formal gardens, along with an extensive rock garden that is considered one of the best in the nation.

FACING PAGE—
Archbishop Thomas A. Boland dedicated Newark's Cathedral Basilica of the Sacred Heart in 1954, after almost a century of planning and construction. The cathedral's spires reach higher than those of Notre Dame or Westminster Abbey. Newark is New Jersey's largest city, with more than a quarter of a million residents.

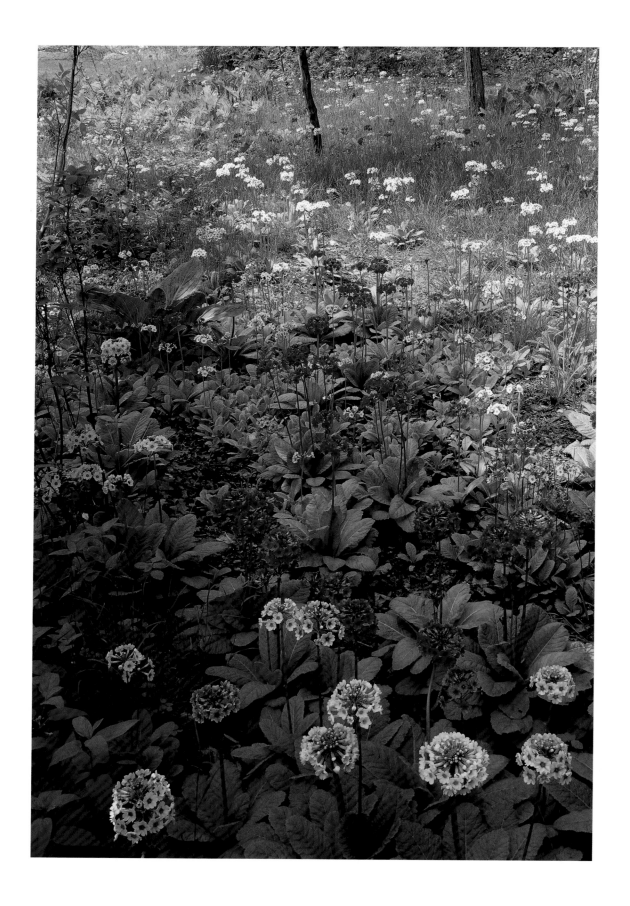

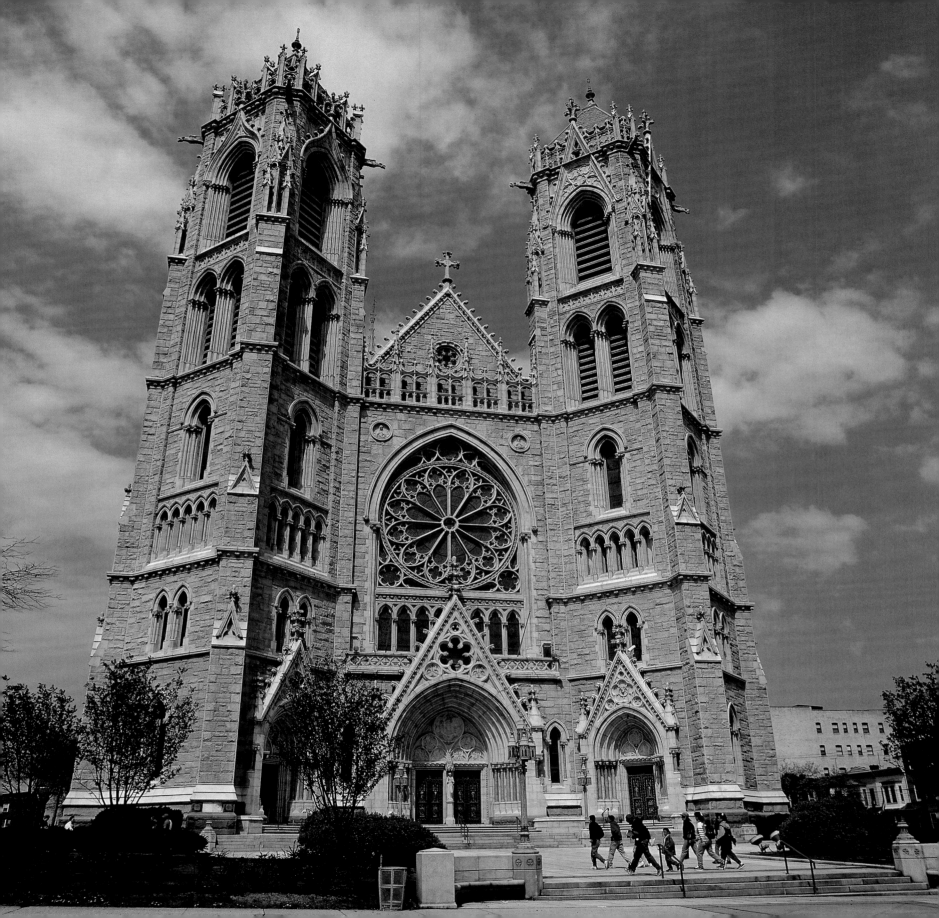

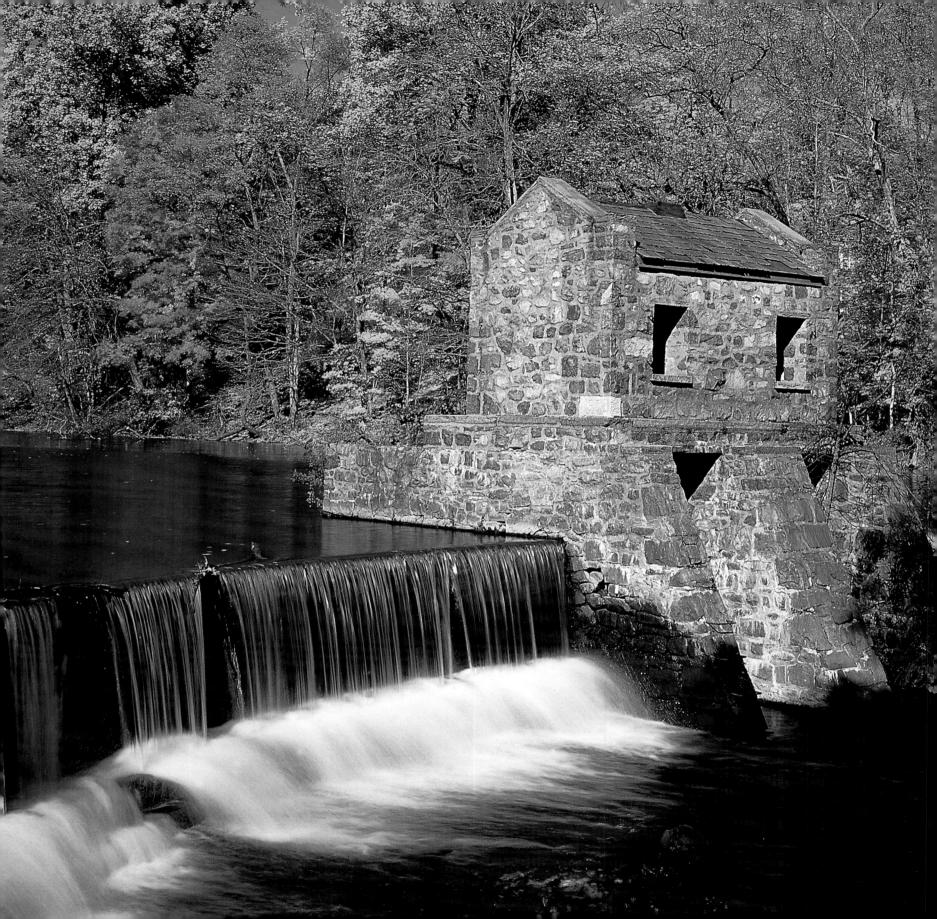

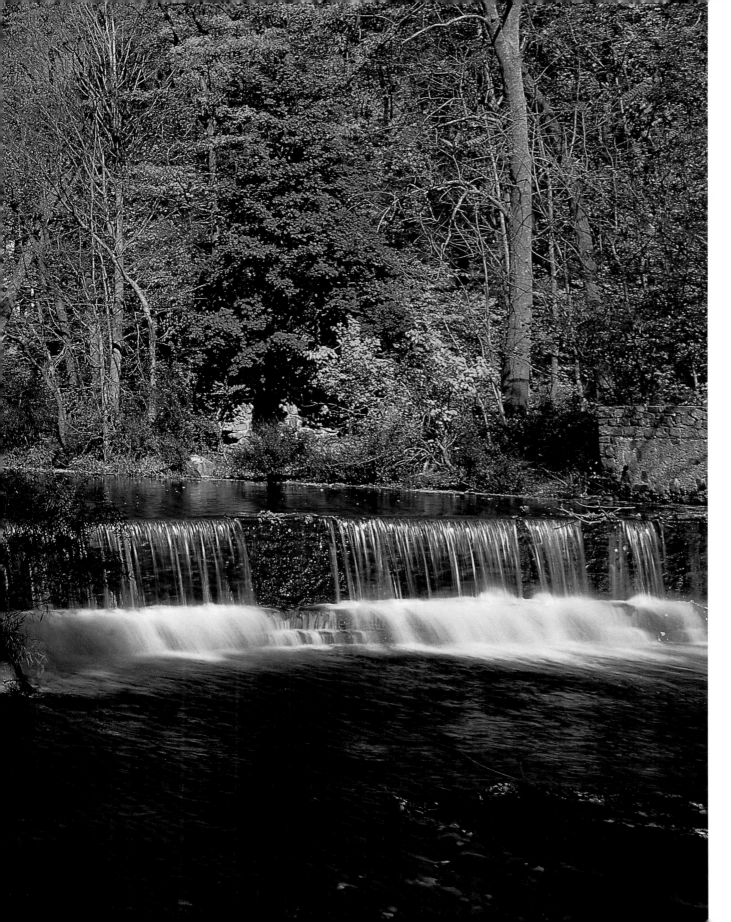

Hand-built stone waterworks along the shores of Speedwell Lake remind visitors of a time when Morris County was a center for iron production. In the nearby town of Speedwell, ironworks heir Alfred Vail and inventor Samuel F. B. Morse worked together to perfect the telegraph in the 1840s.

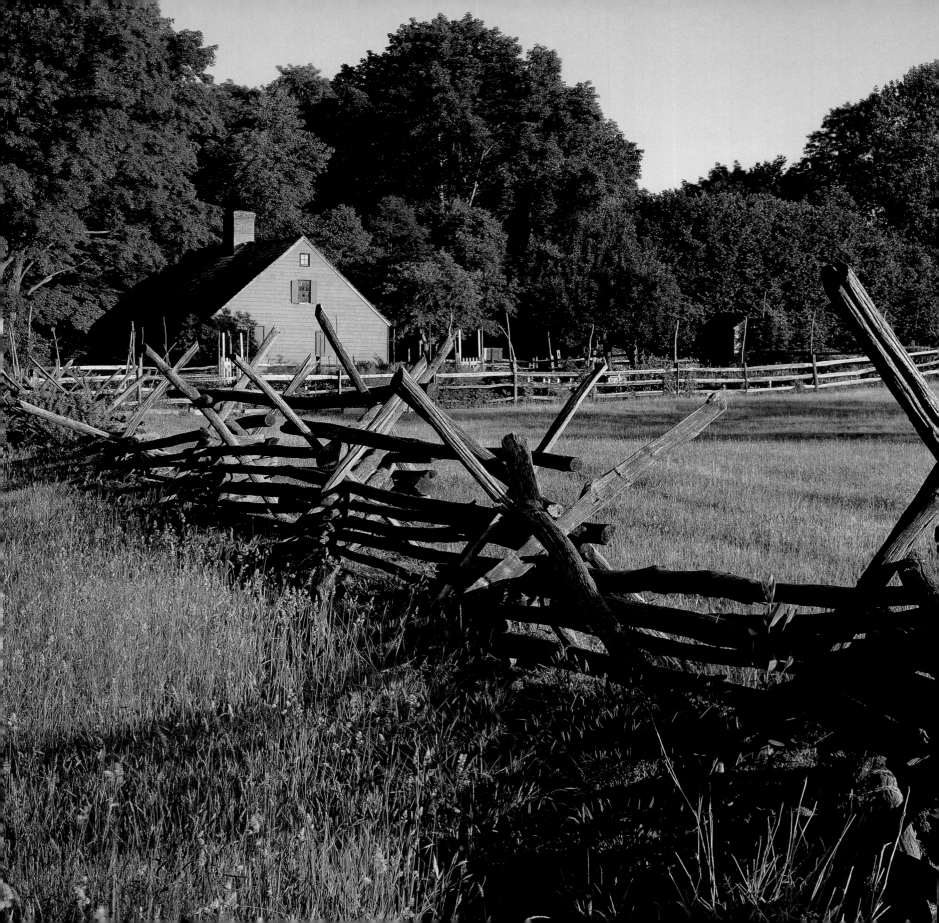

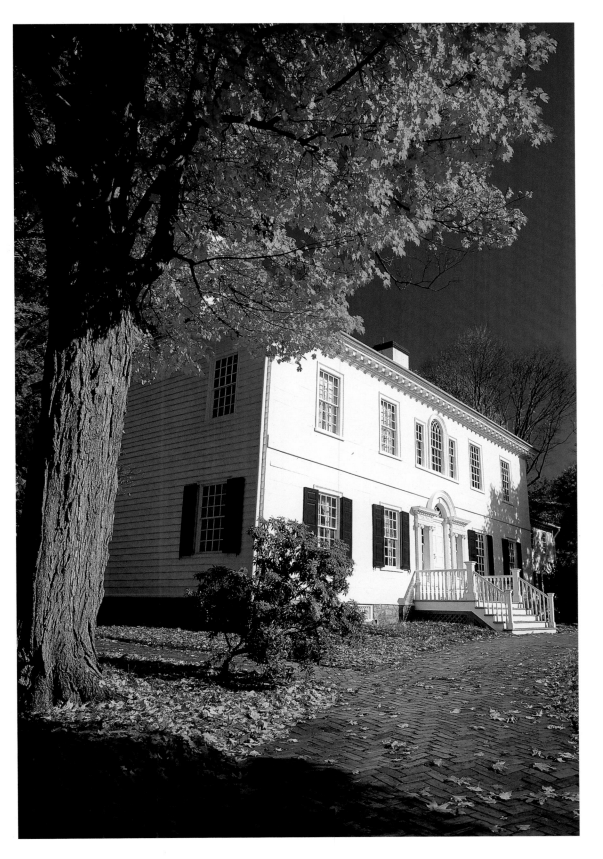

As the winter of 1779 descended upon George Washington and his Revolutionary Army, the leader chose Morristown to withstand the season and plan his next attack. The Jacob Ford Mansion, protected since 1933 by Morristown National Historic Park, served as Washington's headquarters during this time.

FACING PAGE—
Along with military sites and a restored farmhouse, Morristown National Historic Park includes more than 1,000 acres of forests and flood plains. In Jockey Hollow, hiking trails meander through lush vegetation, home to 120 bird species.

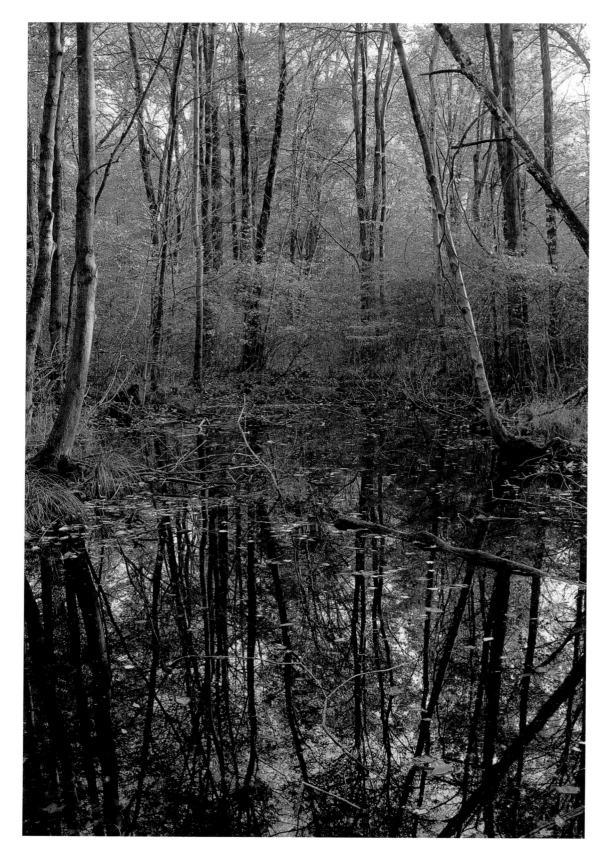

As glaciers retreated 25,000 years ago, they left behind a massive lake, which drained over several centuries to create what is now the 6,818-acre Great Swamp National Wildlife Refuge. In the early 1900s, farming and flood control threatened these wetlands. Concerned citizens raised more than a million dollars to save them.

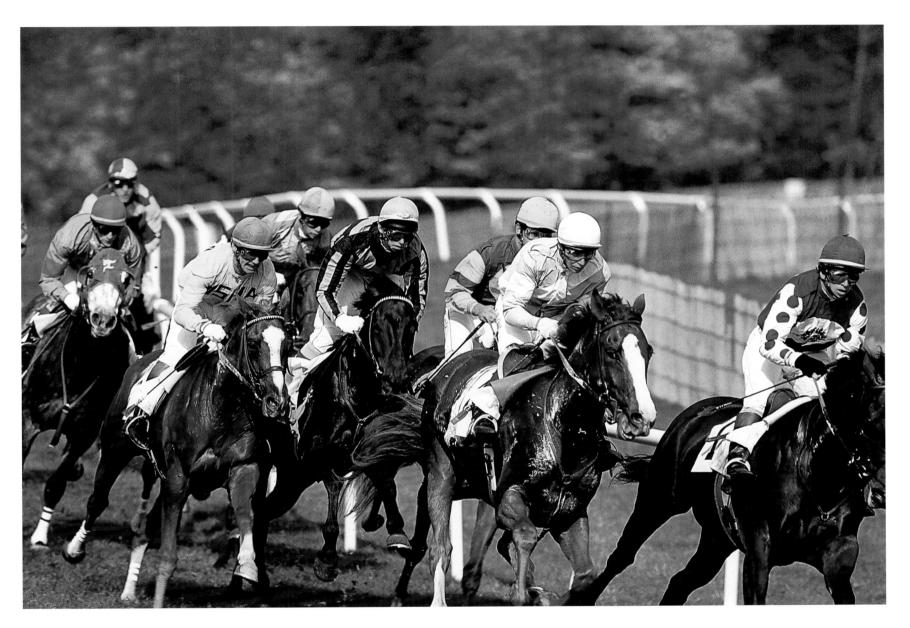

American steeplechasing has drawn crowds since the first races were held in New York State in the late 1800s. Competitions in Far Hills, New Jersey, began in 1899. The races are named for their European predecessors, traditionally cross-country rides to town steeples, the most prominent rural landmarks.

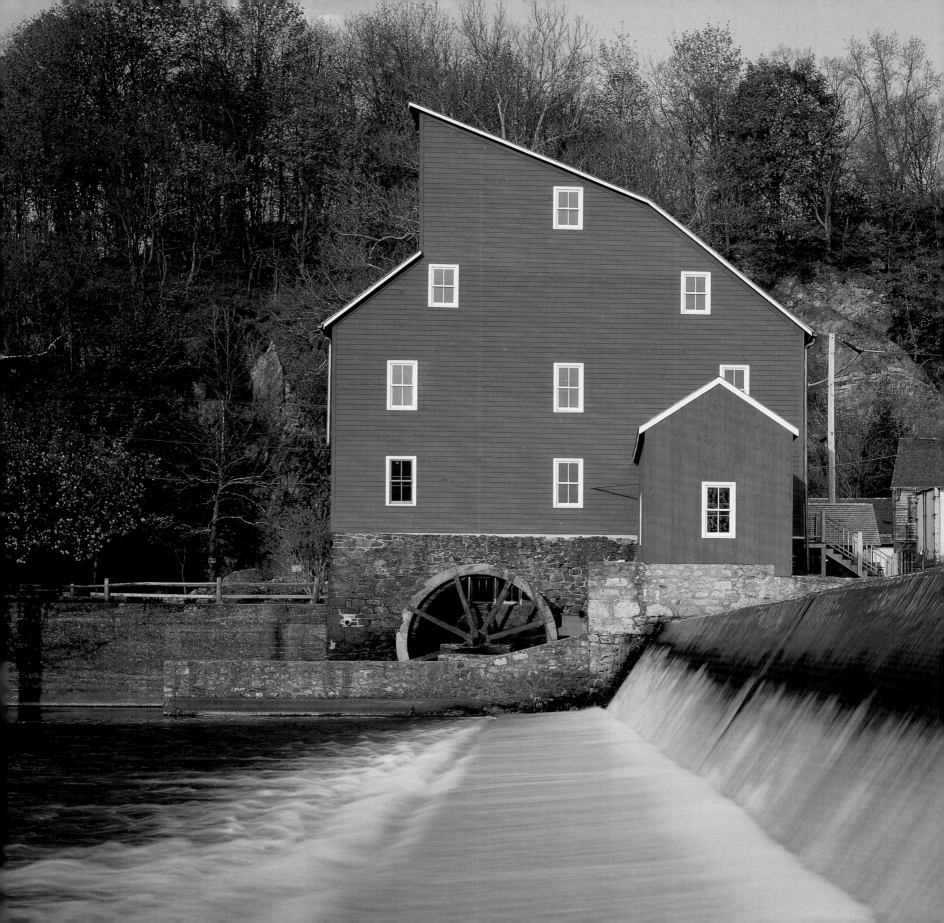

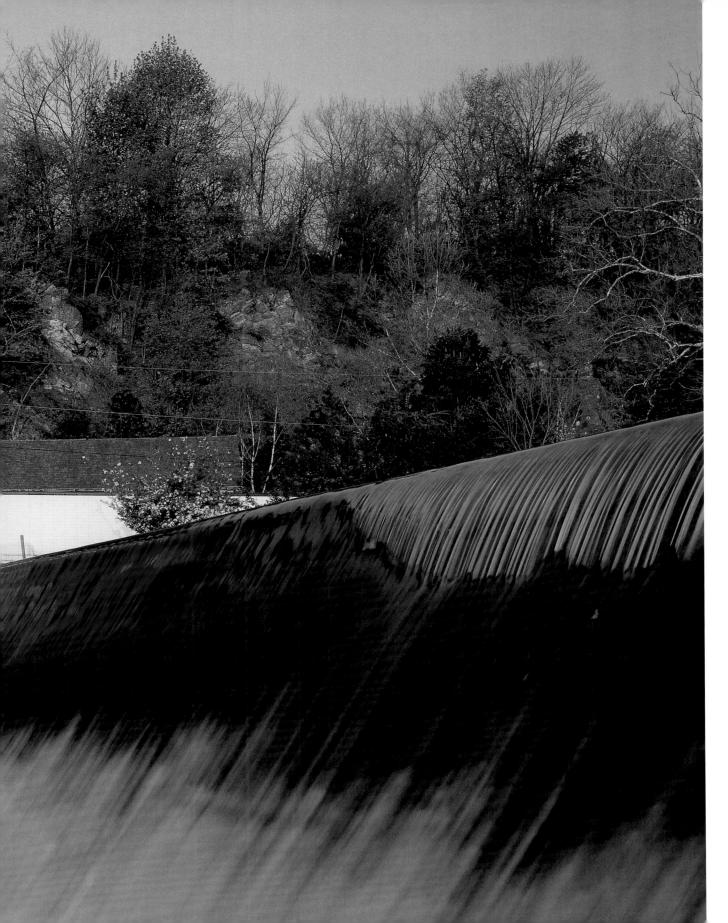

Built in 1812, this mill in Clinton was originally designed to process wool. Later owners renovated it for grist milling, plaster grinding, and even basket making. The mill's distinctive roofline was created in 1908 not for architectural interest, but to allow room for tall machinery.

For over 50 years, more than 500 cyclists from around the world have gathered each Memorial Day for the Tour of Somerville. When the event was created by bicycle-shop owner Fred Kugler, racing wasn't allowed on local streets. The resource-ful Kugler renamed his competition a "tour."

FACING PAGE—
Thomas Edison was already famous for his invention of the incandescent light bulb when he moved his laboratories to West Orange in 1887. Here Edison and his staff created the motion picture camera, perfected the phonograph, created movies, and invented the alkaline battery.

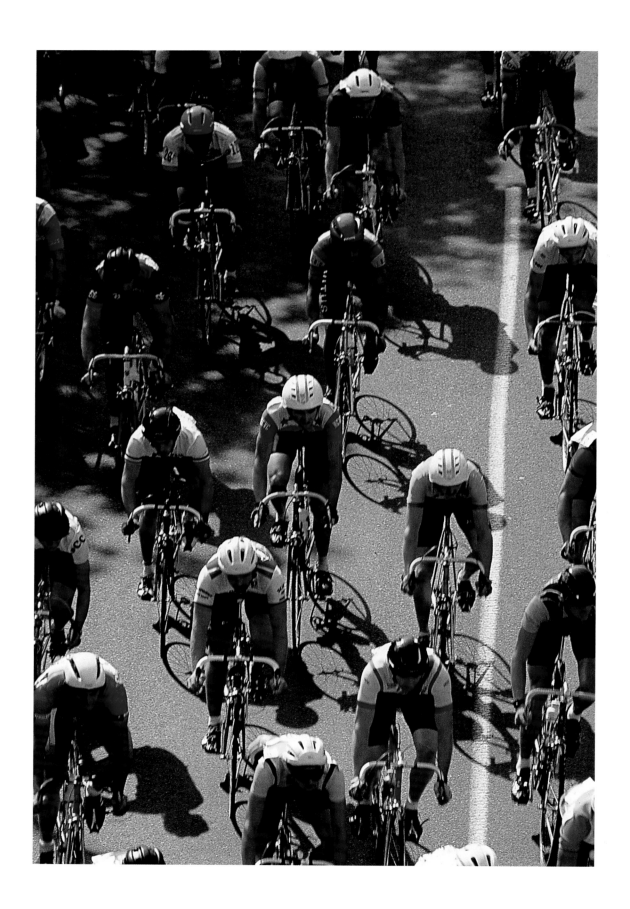

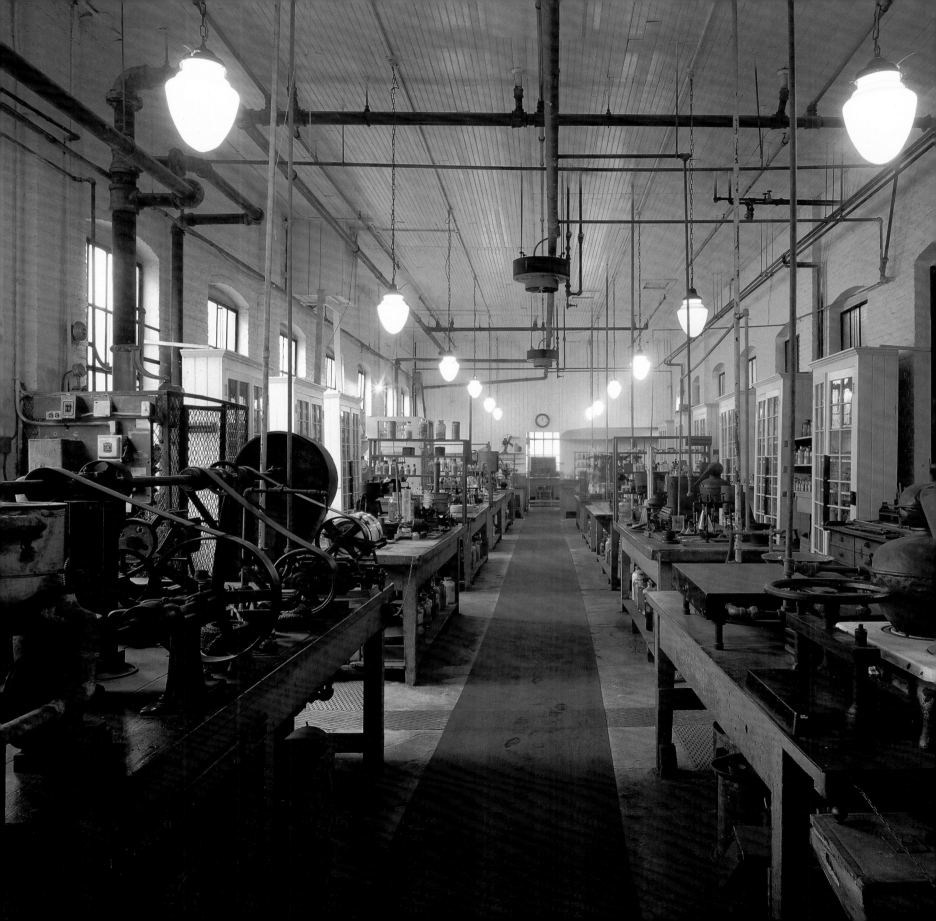

Along the Atlantic coast, New Jersey boasts 127 miles of white sand beaches, collectively known as the Jersey Shore. Charming bed and breakfasts, seafood restaurants, majestic lighthouses, and more, make this region a vacation haven.

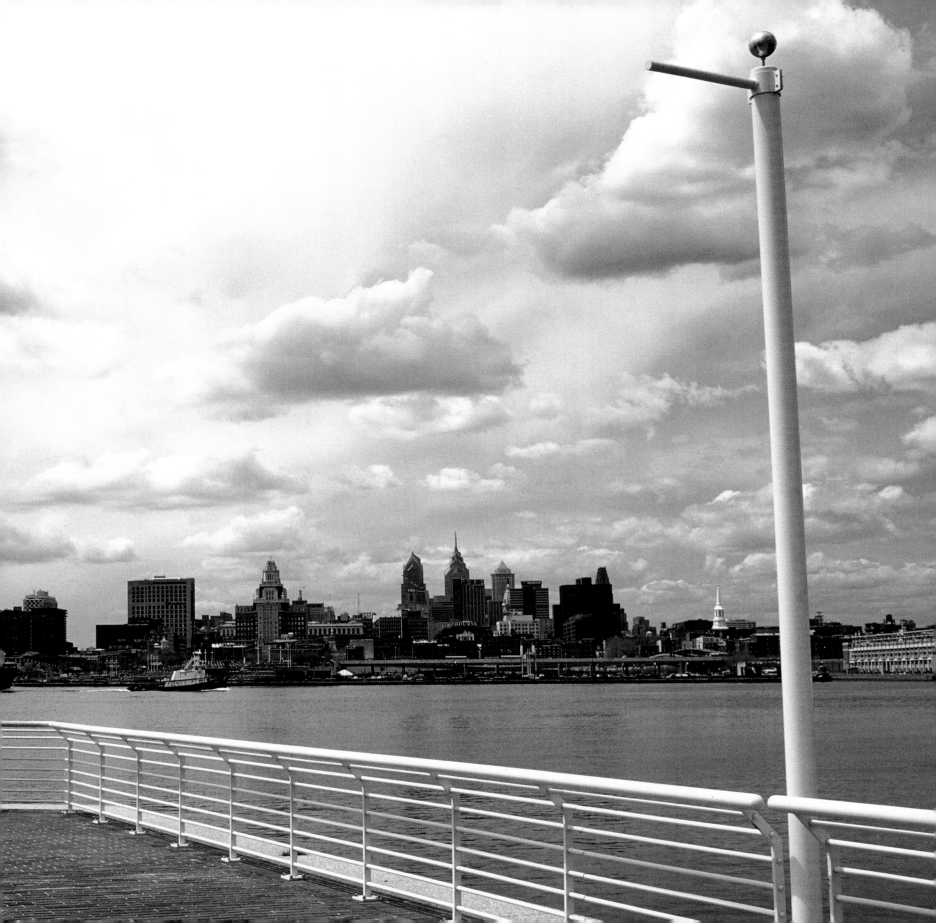

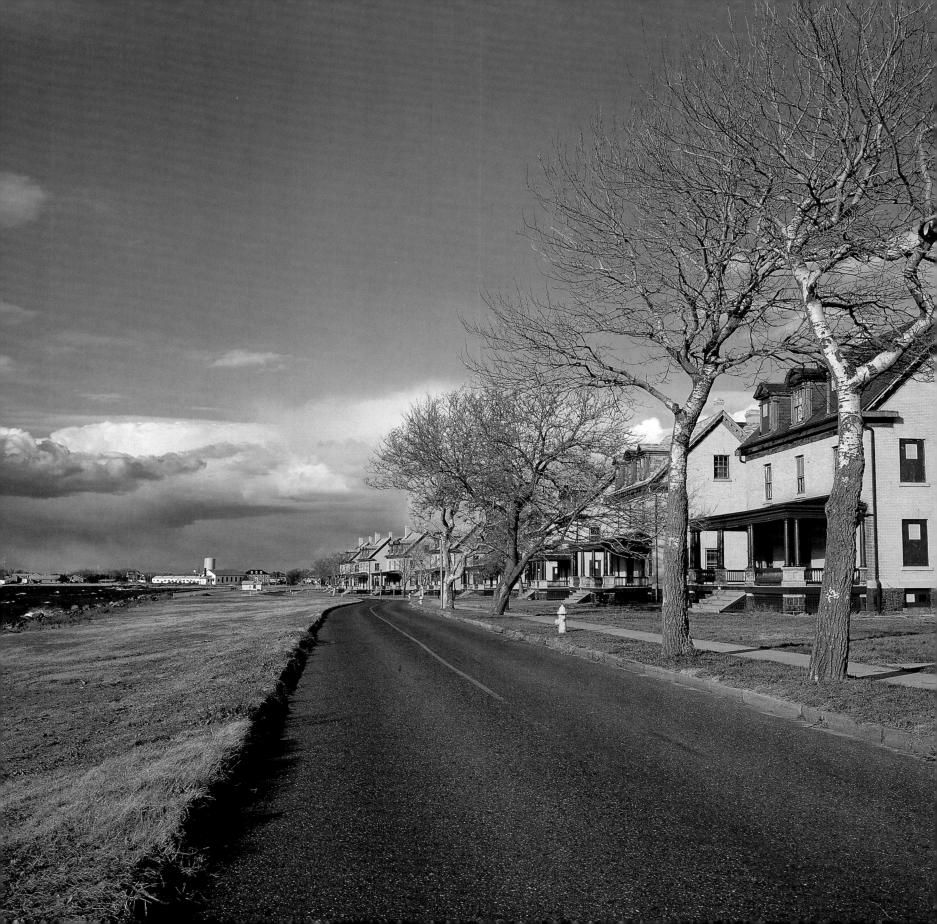

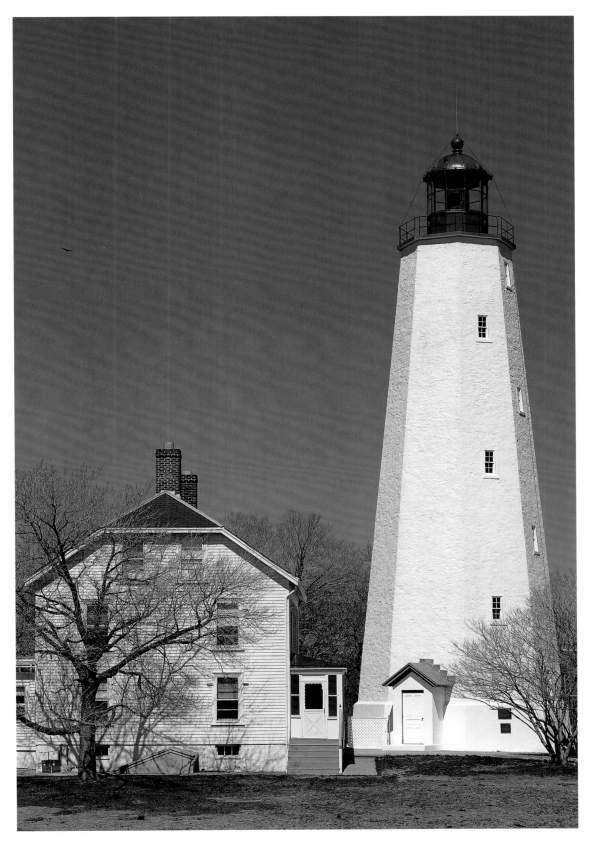

The oldest operating beacon in the nation, Sandy Hook Lighthouse has stood at the tip of New Jersey's Sandy Hook peninsula since 1764, guiding vessels toward the port of New York. British forces occupied the lighthouse during the Revolutionary War.

FACING PAGE—
Bordering the urban areas of New Jersey's Monmouth County and Brooklyn, Queens, and Staten Island, New York, Gateway National Recreation Area protects some of the region's best beaches and natural areas. The 26,000-acre preserve offers swimming, sailing, surfing, hiking, and horseback riding facilities, along with military landmarks, sports fields, and cultural venues.

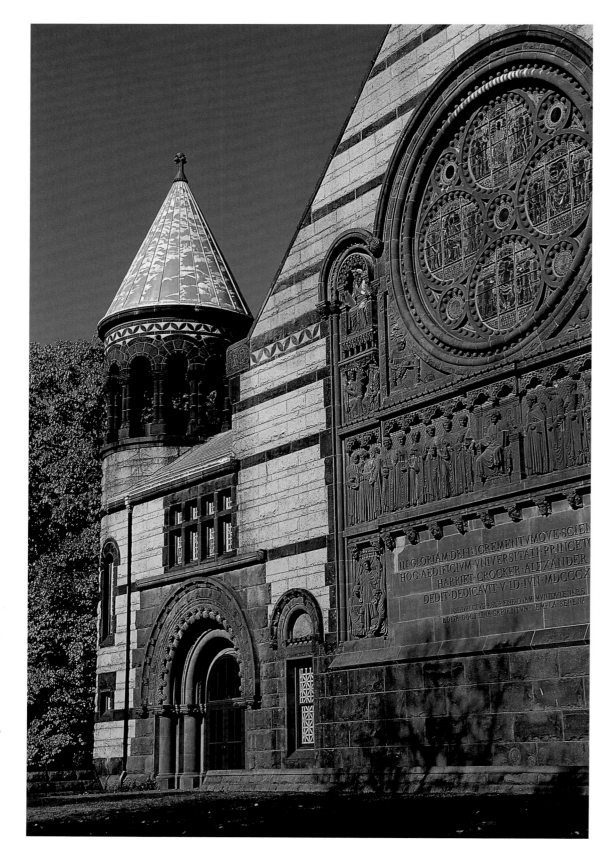

The College of New Jersey opened its doors in 1746 in the town of Elizabeth. It moved to Newark, then to Princeton, and 150 years after it was founded, the institution changed its name to Princeton University. Today, alumni and faculty include two former presidents and more than 30 Nobel Prize winners.

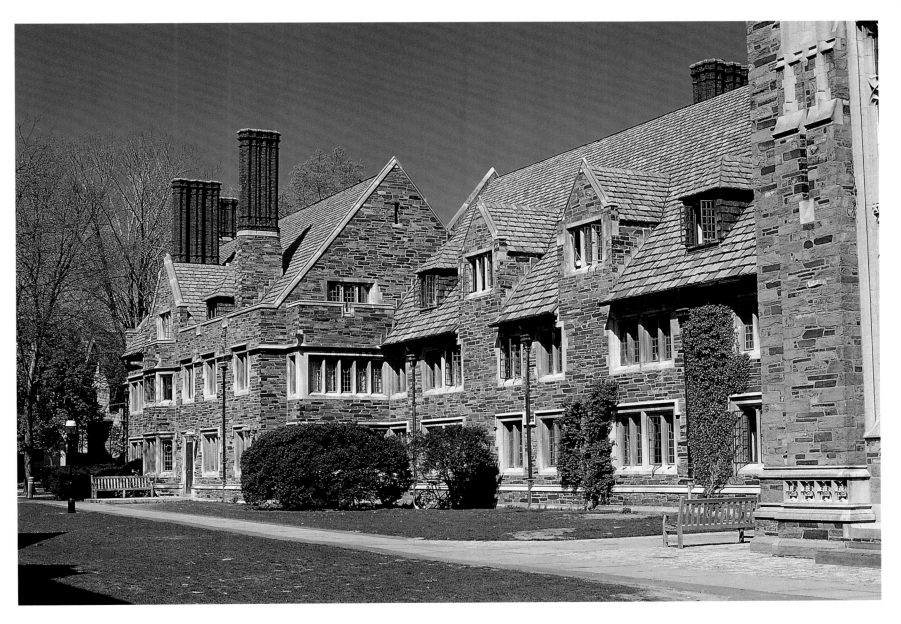

About 4,600 undergraduates and 2,000 graduate students attend Princeton University. The Ivy League university's student body represents every New Jersey county, most of the nation's states, and more than 60 foreign countries.

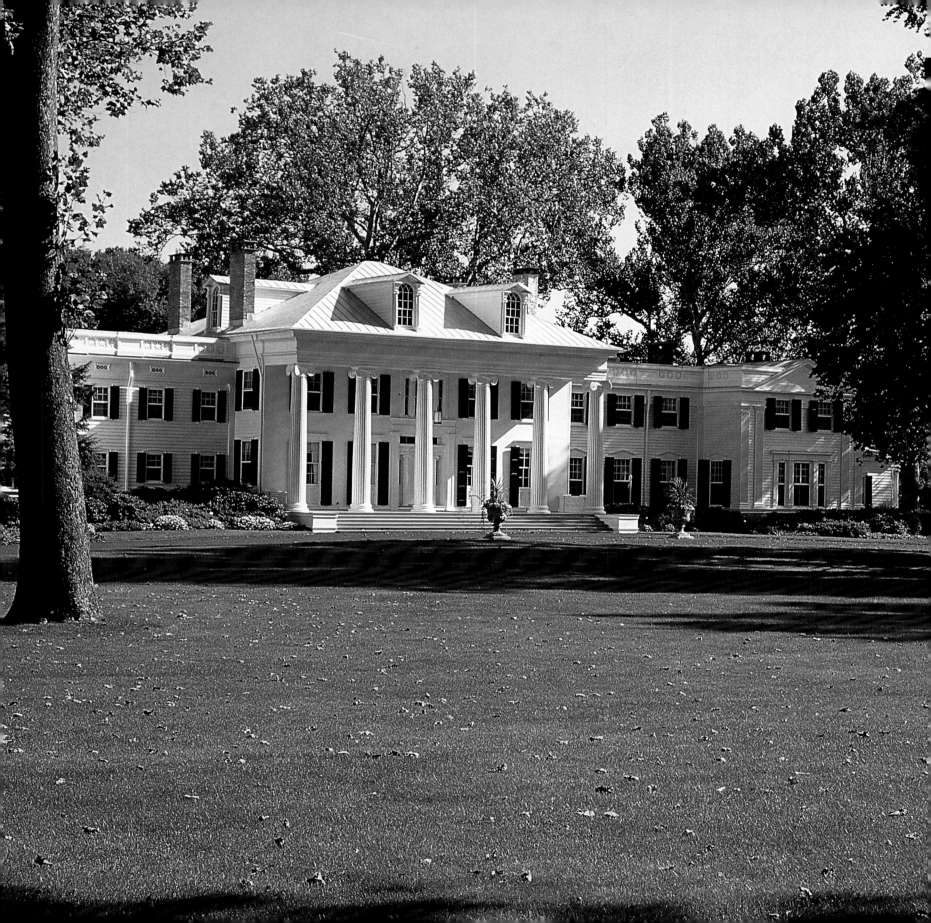

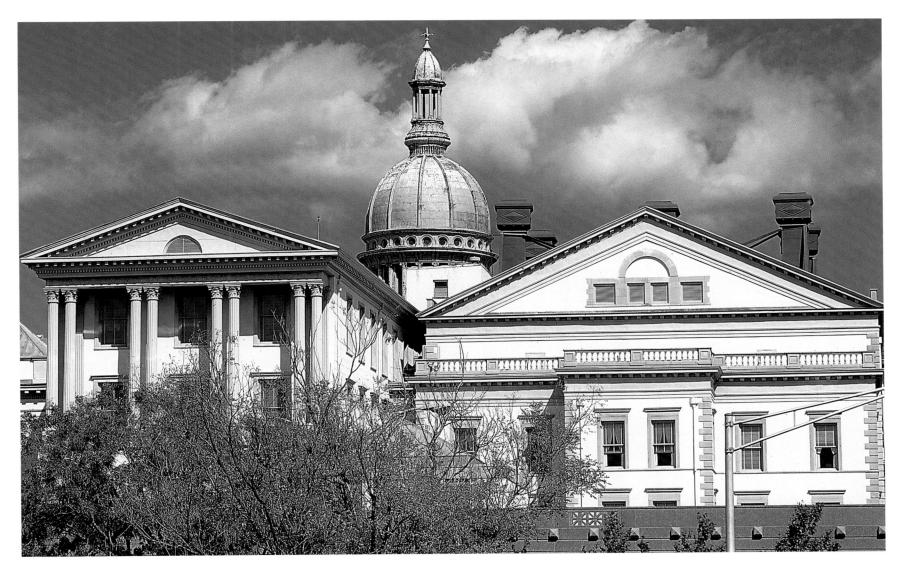

When New Jersey's State Capitol was built in 1792, it was a modest building with a small bell tower adorning two stories of chambers and offices. After fire destroyed much of the building in 1885, architect Lewis Broome added a new wing, a limestone façade, and a large rotunda.

Princeton's Drumthwacket mansion is the official residence of the governor of New Jersey. The opulent mansion was built in 1835 by Charles Smith Olden, a descendant of some of Princeton's first settlers.

From the floor of the rotunda, the cupola of the State Capitol's dome soars 145 feet above. Trenton was selected as the center for state government after the United States declared independence, and the former colonies of East and West Jersey united.

FACING PAGE—
In December 1776, it seemed that the American Revolution was over—the British occupied almost all of New Jersey. Two decisive battles led by George Washington turned the tide and, by early January, the Revolution was underway once more. At the Old Barracks Museum in Trenton, visitors can explore the site's pivotal history.

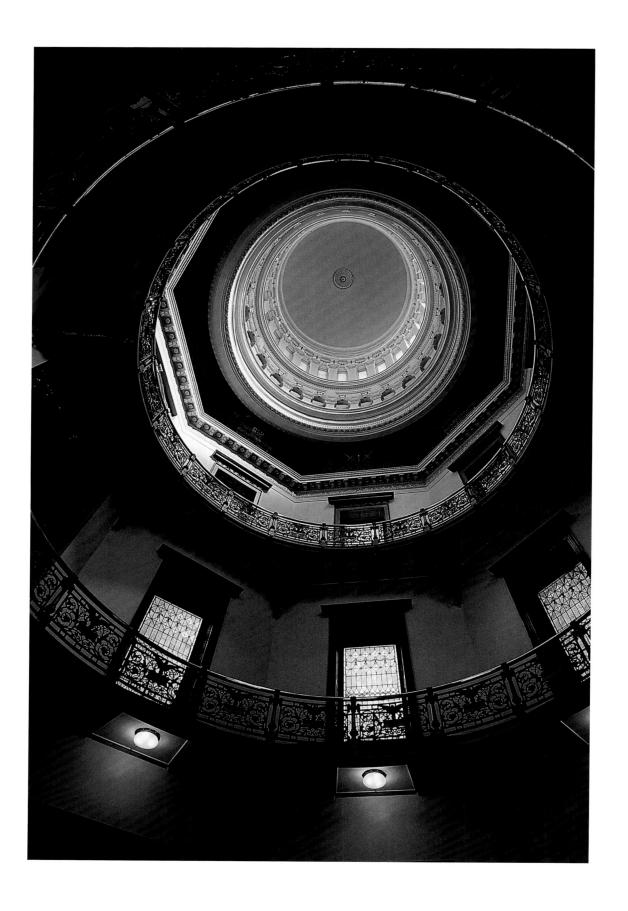

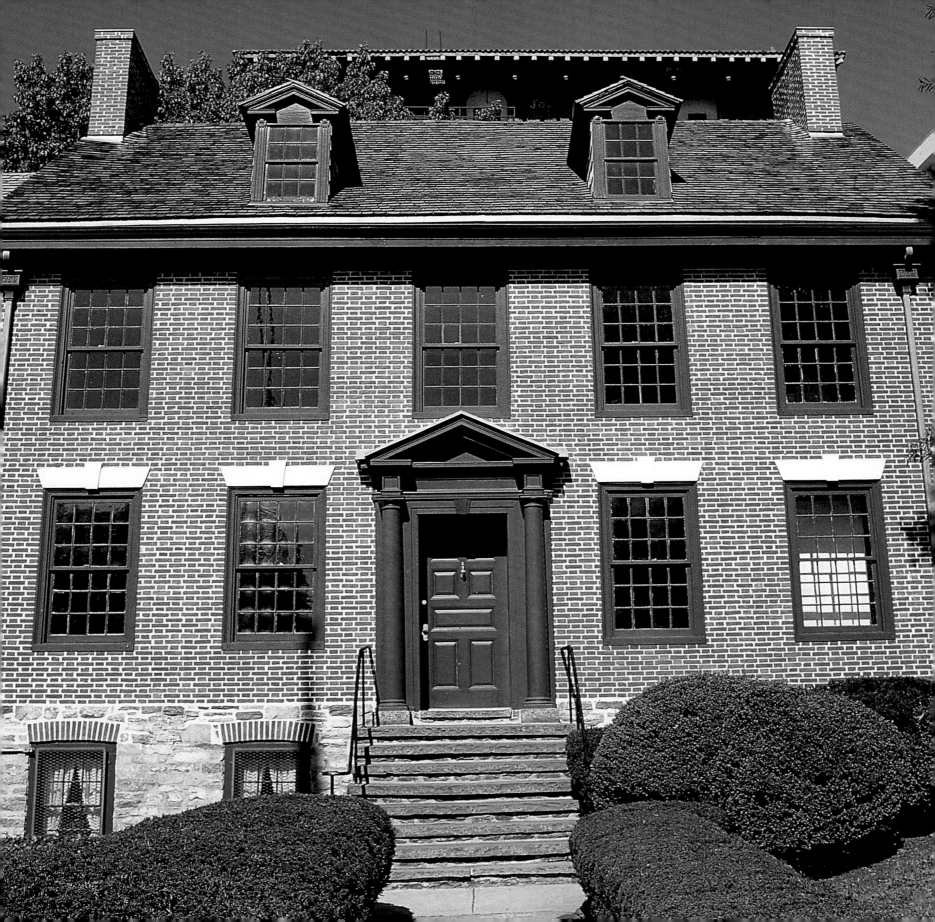

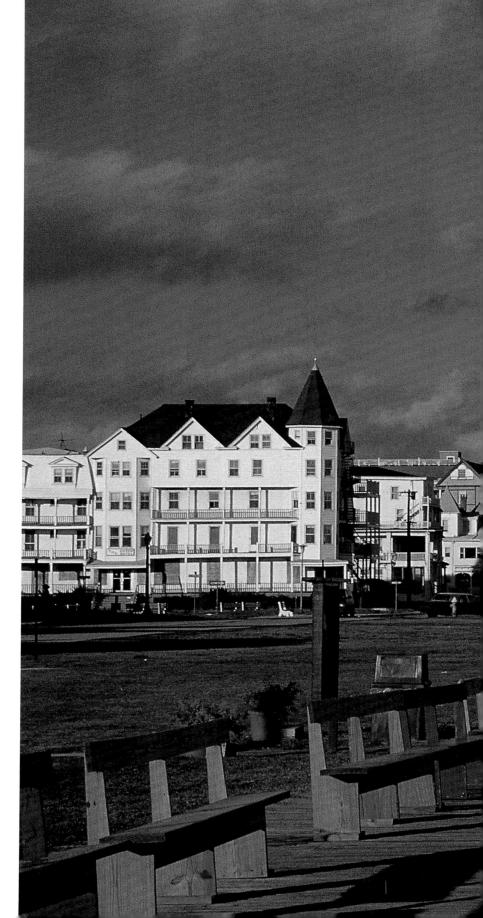

In 1869, Reverend William B. Osborn had found such success with his Methodist revival camps, he decided to found a permanent religious retreat along the Jersey Shore. After followers pitched their tents and began construction, they named the new settlement Ocean Grove. Today, the community is a family vacation destination.

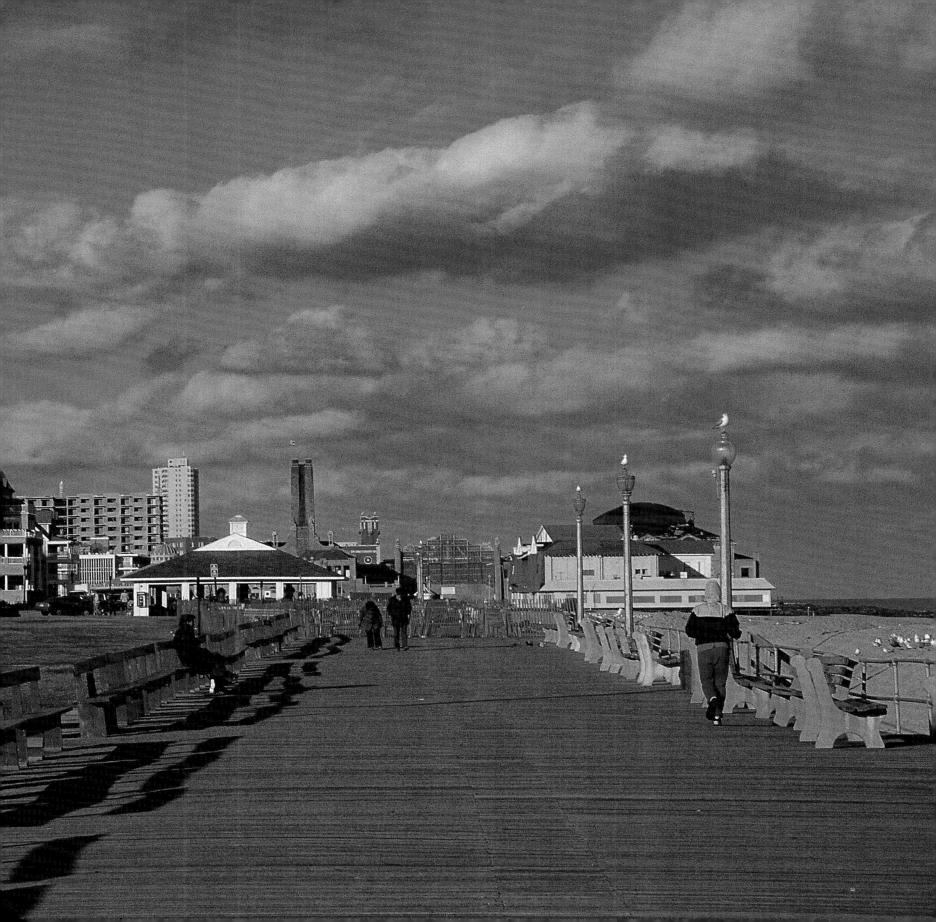

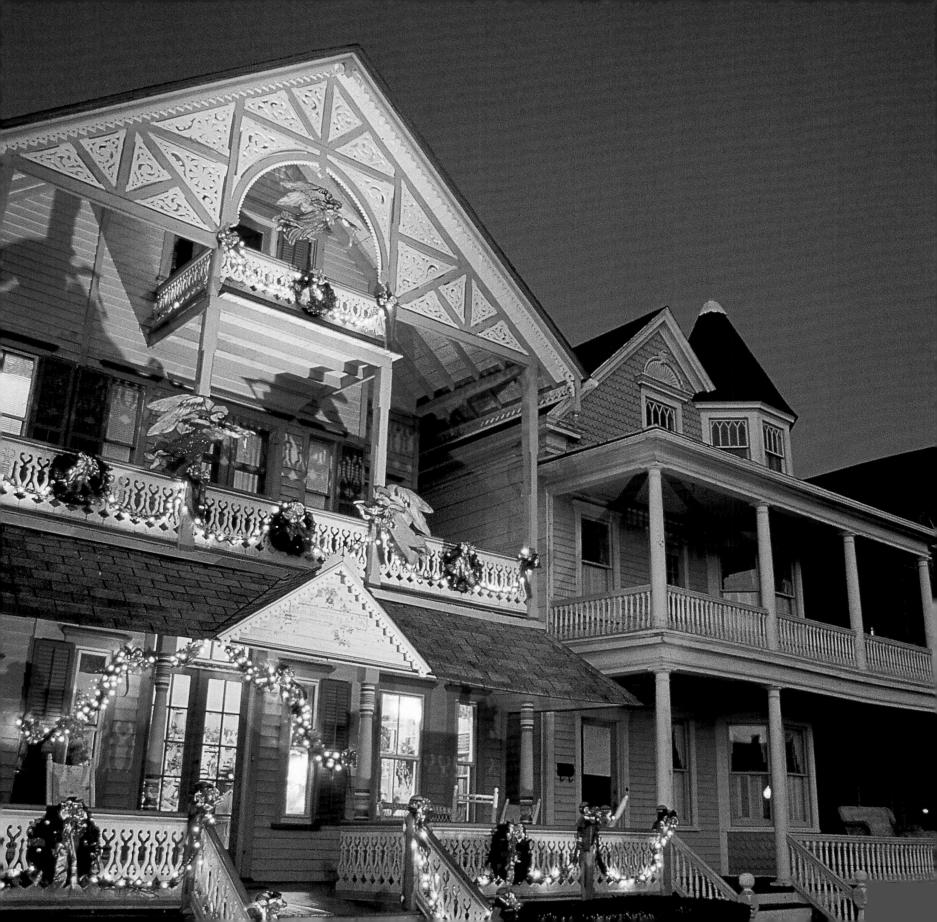

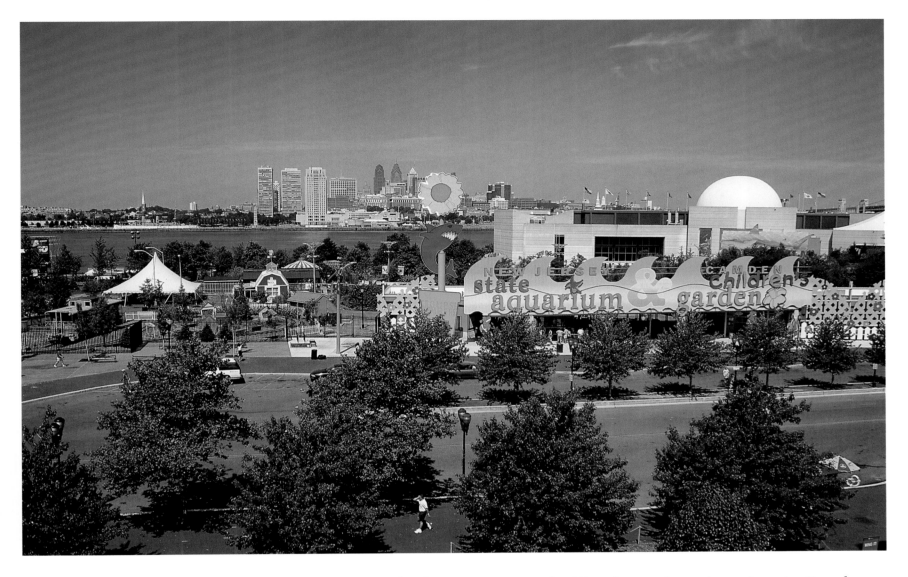

From sharks to penguins, the New Jersey State Aquarium in Camden provides an up-close look at the denizens of the world's oceans. The Open Ocean Exhibit alone features more than 1,500 creatures.

By the end of 1870, enthusiasts had purchased more than 2,000 lots in Ocean Grove, and homes sprang up along the shore. The community adhered to strict religious principles. According to local legend, President Ulysses S. Grant arrived to discover that carriages weren't allowed on Sundays, so he walked to town.

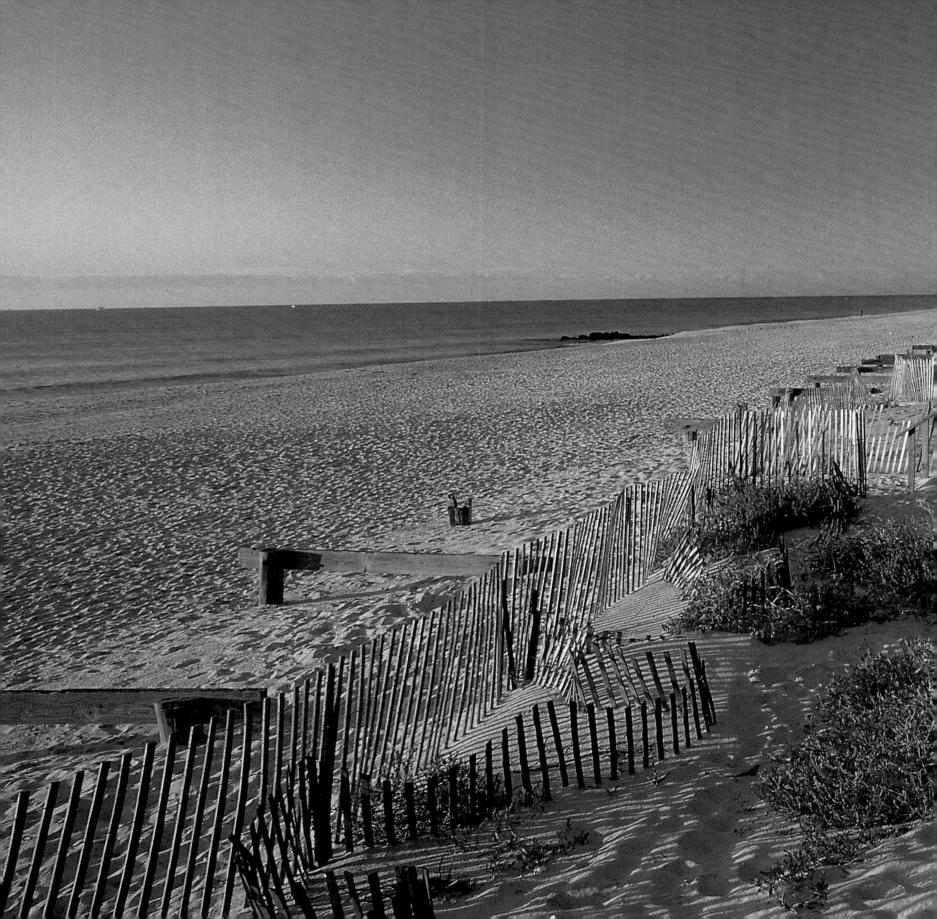

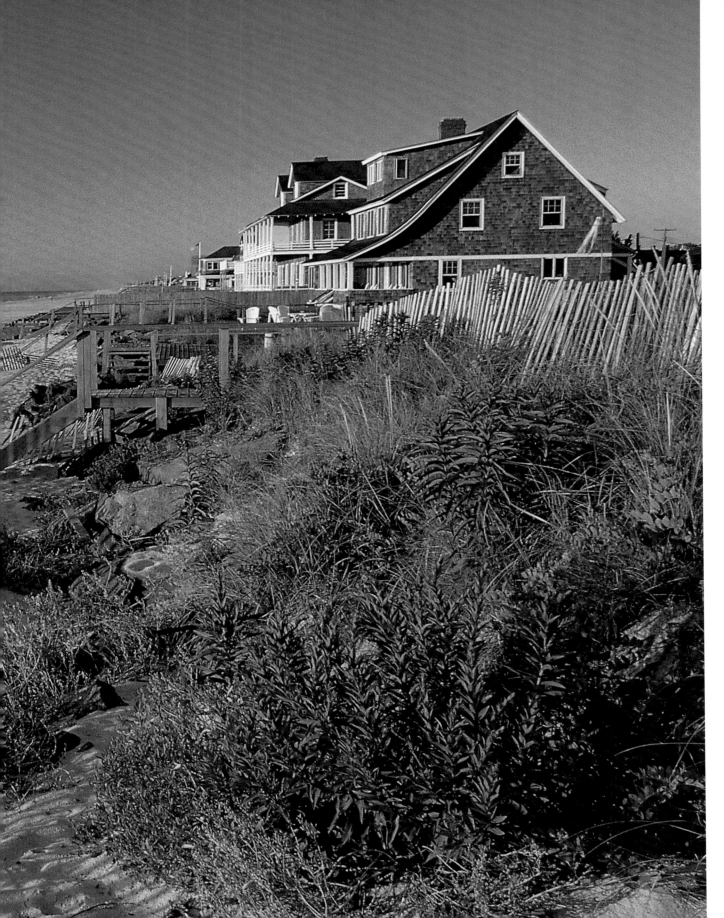

Billed as a country village by the sea, Bay Head offers quaint historic homes, streets lined with well-tended gardens, and the shores of Barnegat Bay and the Atlantic Ocean. The town has been a favorite summer retreat since families from New York City and Philadelphia began traveling here after the Civil War.

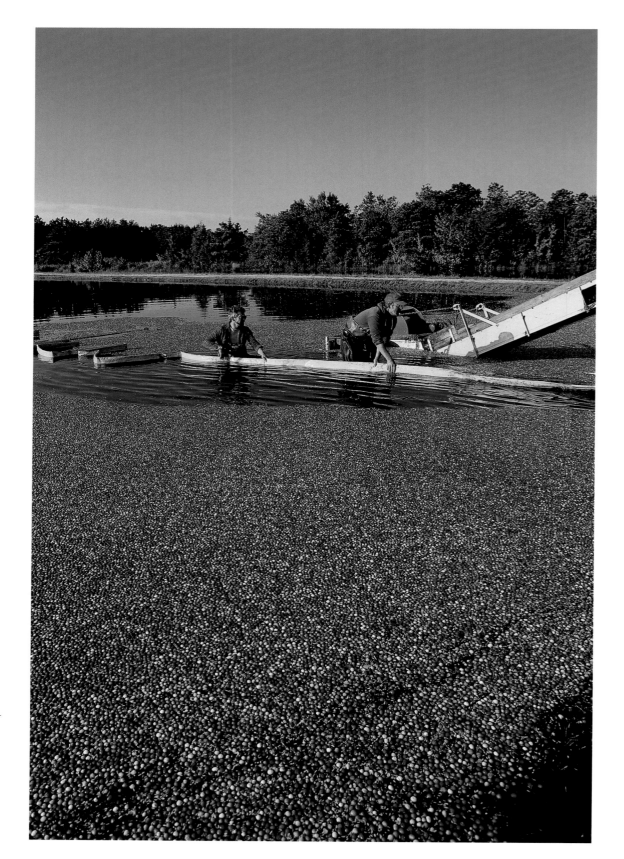

Growers in Burlington County flood the bogs to harvest the ripening cranberries. To the Lenni-Lenape native people who first inhabited this land, the cranberry was not only a source of food, but a symbol of peace. Residents began to commercially farm the berries in the 1830s, marketing them to whalers as a cure for scurvy.

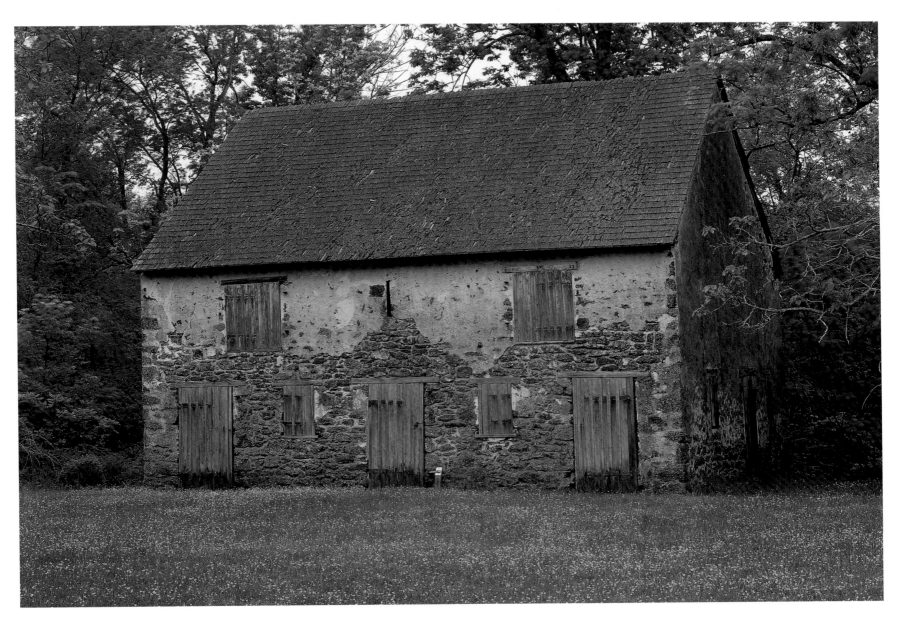

Industrialist Charles Read established the Batsto Iron Works in 1766. William Richards purchased the plant in 1784, and he and his family earned their fortunes making household items and supplying munitions for the War of 1812. A nearby glass factory shipped windowpanes and lamp shades to buyers along the east coast.

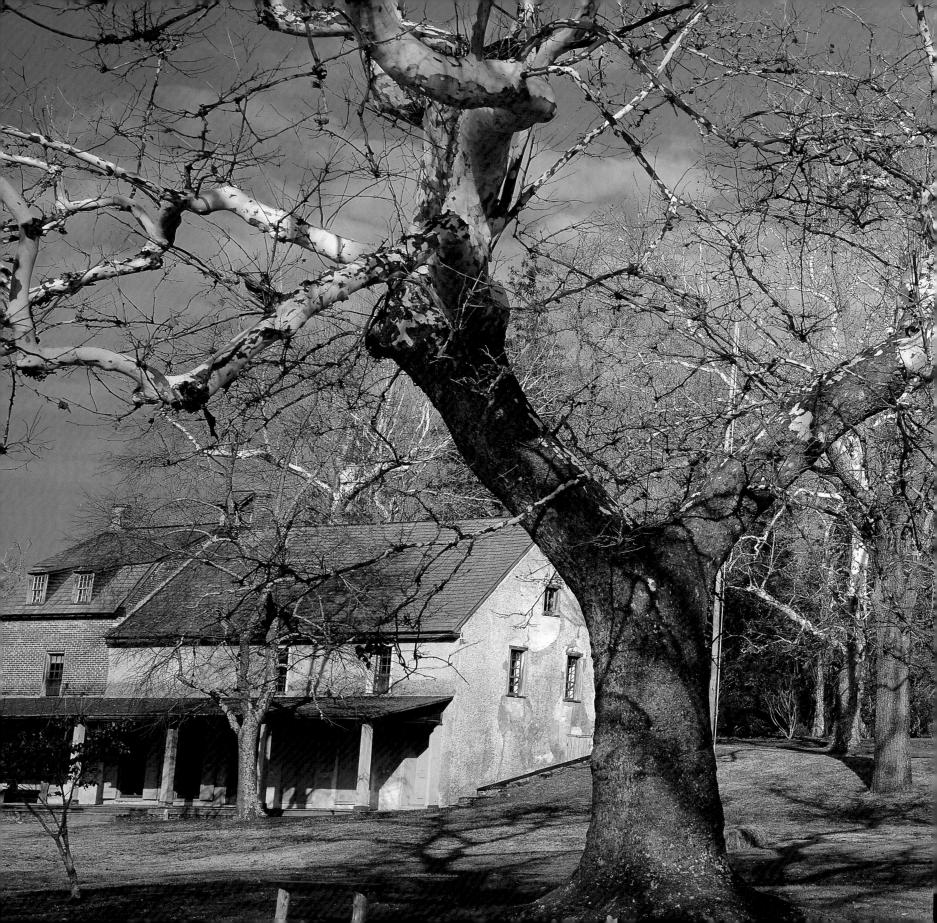

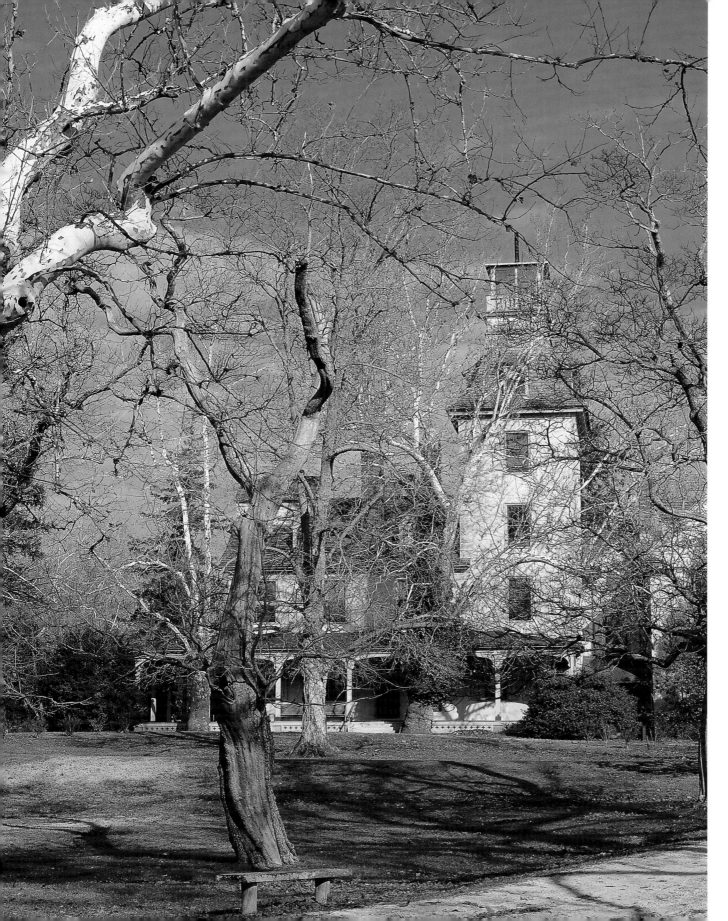

In 1954, the State of New Jersey bought the site of Batsto, within Wharton State Forest, to preserve an iron refining town. Workers restored the village and visitors can now explore the historic mansion, barns, and industrial sites.

65

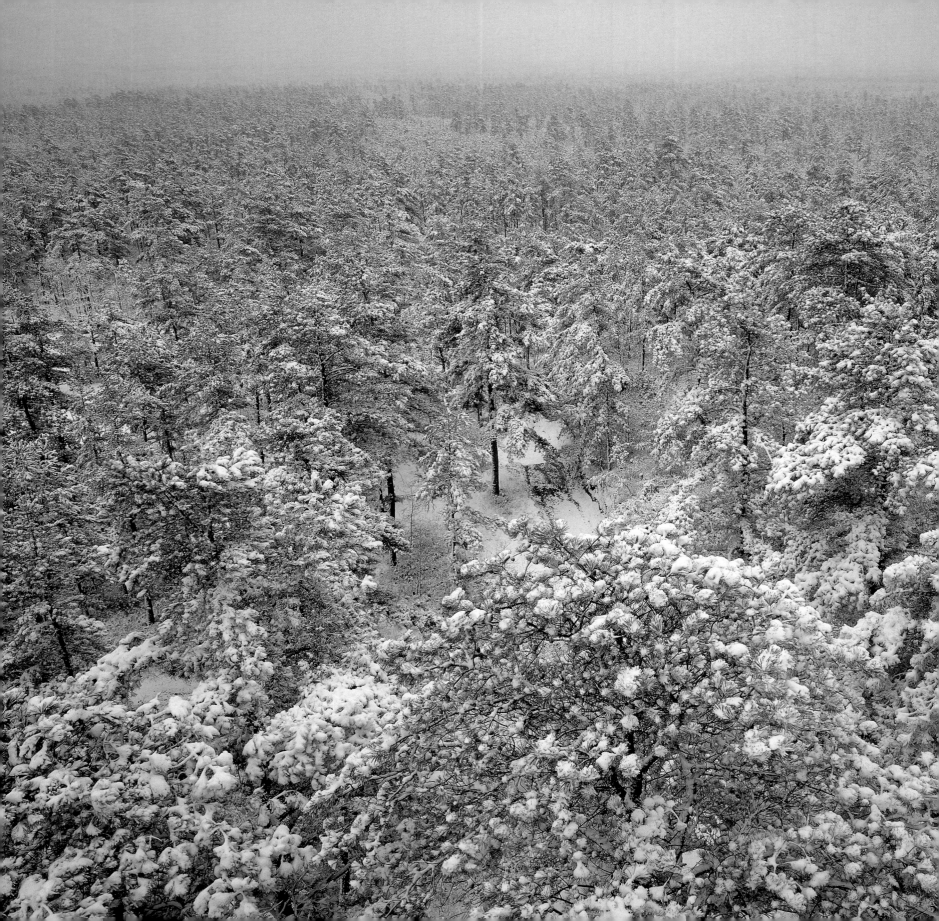

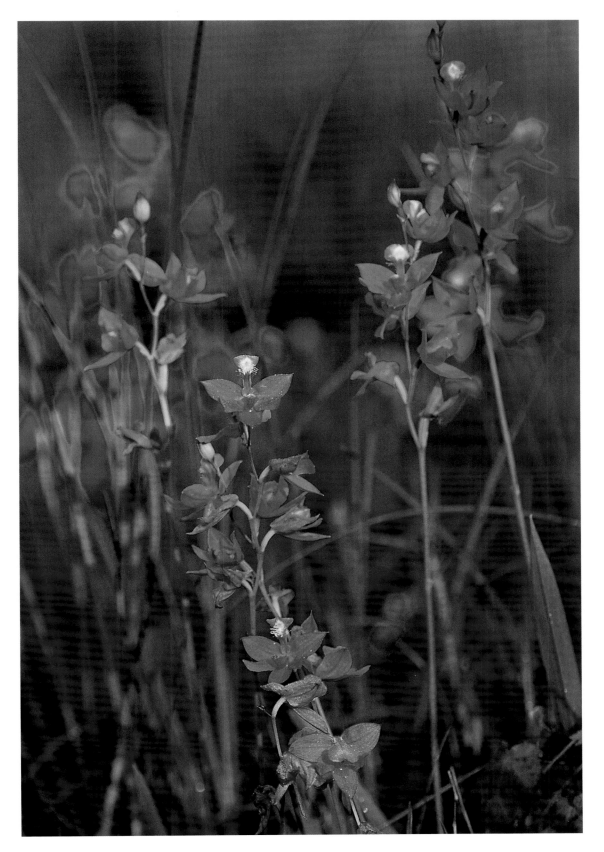

This grass pink orchid is one of more than 850 plant species that flourish in the unique ecosystems of the Pine Barrens. The 350 bird and animal species that live here include the rare timber rattlesnake and Pine Barrens tree frog, creatures that have found refuge here since the region was protected in 1978.

FACING PAGE—
Designated a Biosphere Reserve by the United Nations, Pineland National Reserve in southern New Jersey encompasses 1.1 million acres—22 percent of the state. Here, bogs and marshes fed by underwater streams slowly give way to expansive pygmy forests, where thousands of pines and oaks grow only five to 10 feet tall.

Ten miles long, Island Beach State Park faces the wind and waves of the Atlantic, protecting quiet Barnegat Bay to the west. Unlike most of the barrier islands along America's Atlantic coast, this one remains undeveloped. Its white sand beaches and fresh- and saltwater marshes are home to osprey, peregrine falcons, and threatened piping plovers.

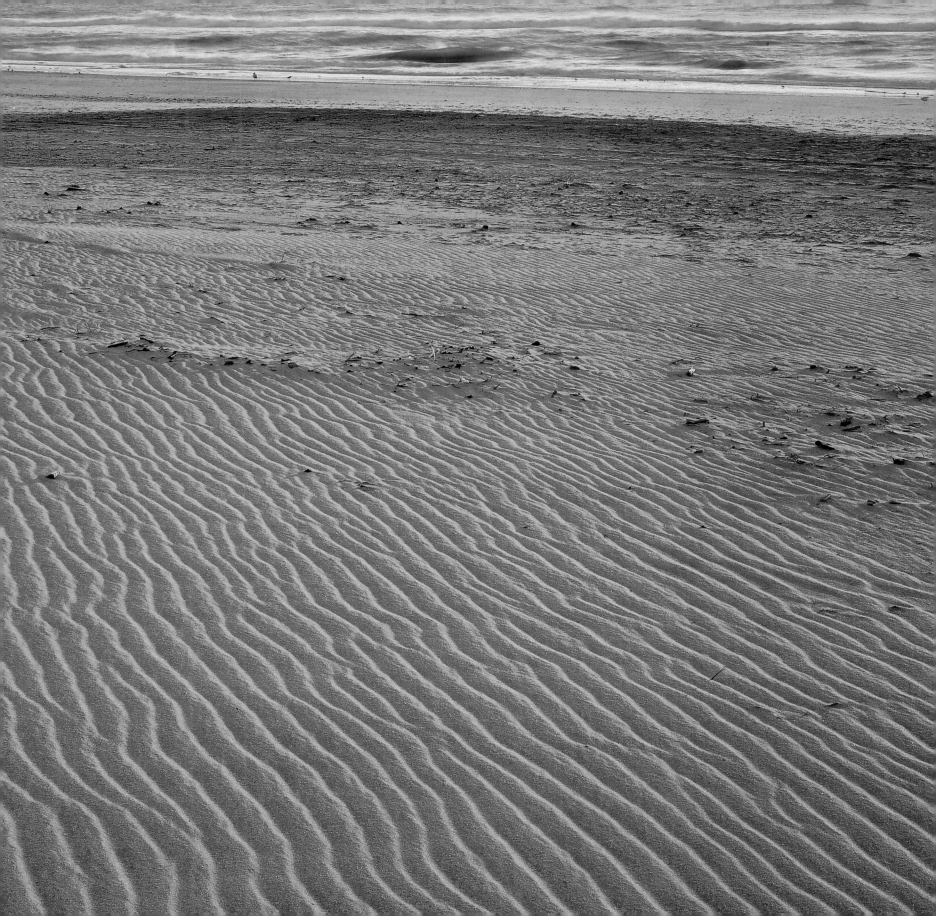

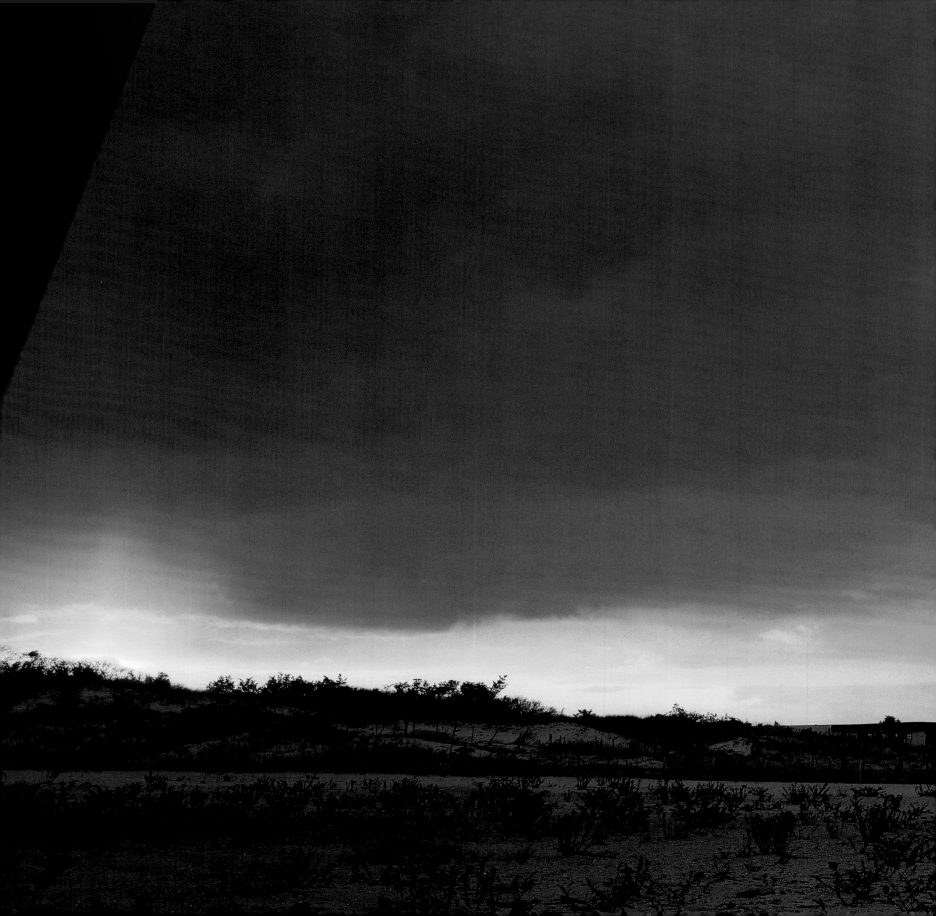

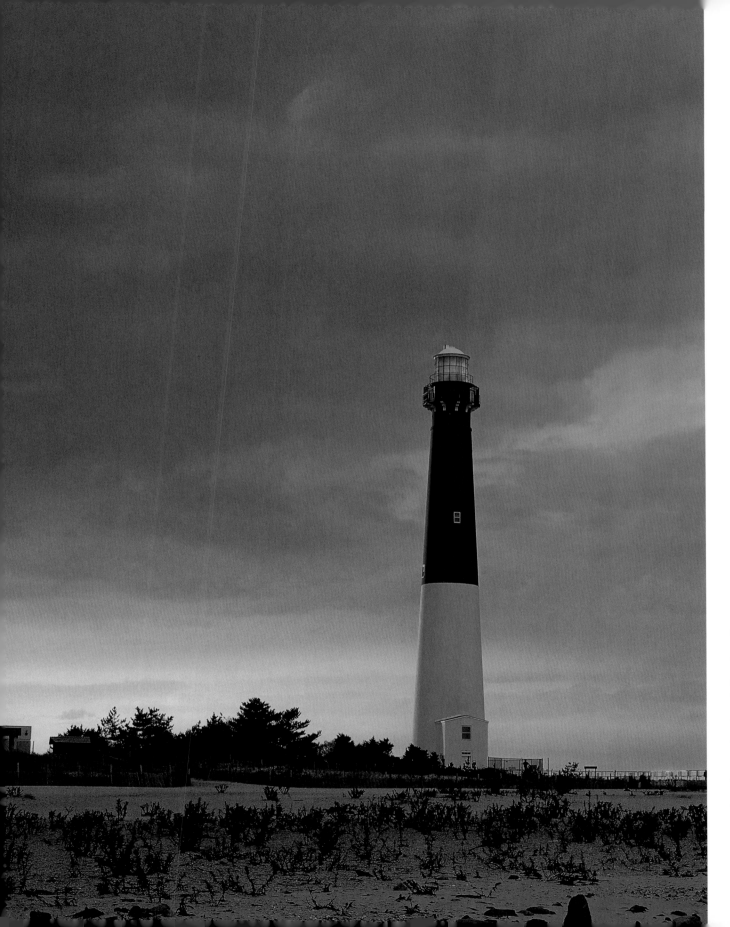

The shifting sands of Long Beach Island sent the original lighthouse on this point tumbling into the ocean waters in 1856. The present beacon, 165 feet tall, was built in 1859.

71

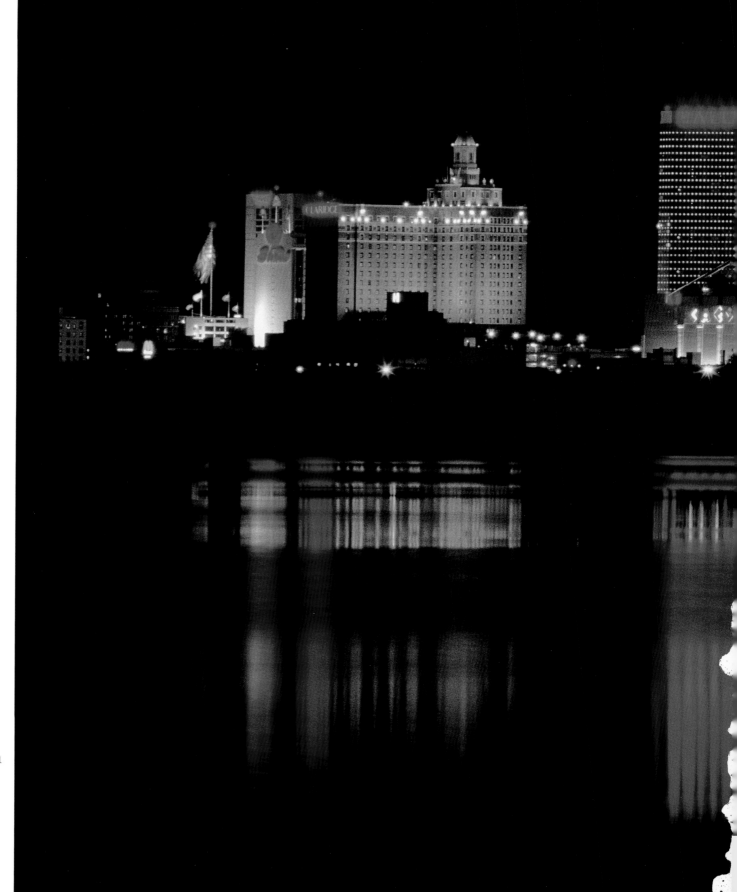

Vacationers discovered Atlantic City when the Camden and Atlantic Railway arrived in 1854. Development lagged in the mid-1900s, but boomed once more when gambling was legalized in 1978.

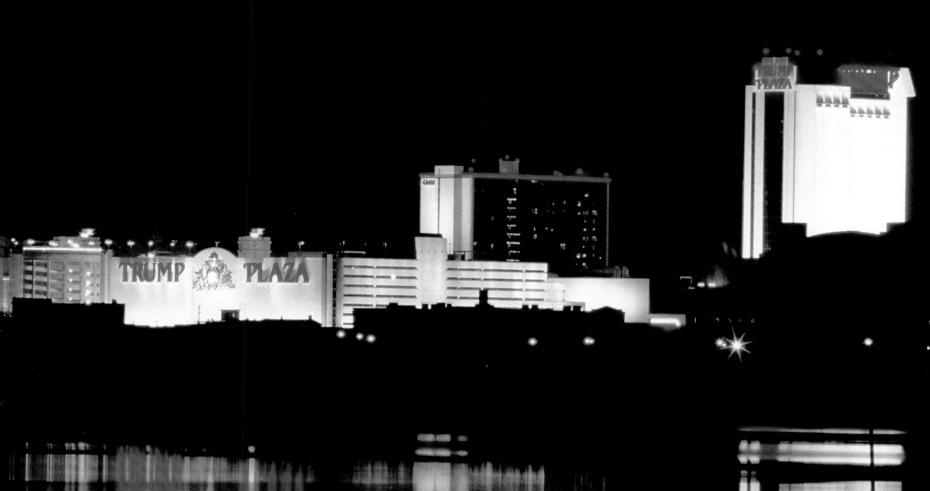

Trump Taj Mahal Hotel Casino Resort opened its doors in 1990. The extravagant 17-acre metropolis boasts 1,250 guest rooms, an arena, convention facilities, and one of the world's largest casinos. More steel was used to construct the hotel than was used to build the Eiffel Tower.

FACING PAGE—
Lucy the Elephant is the only pachyderm ever declared a national historic landmark. A local land owner built the structure in 1881, hoping to attract real estate buyers. Visitors can climb the stairs in Lucy's legs to reach the rooms above.

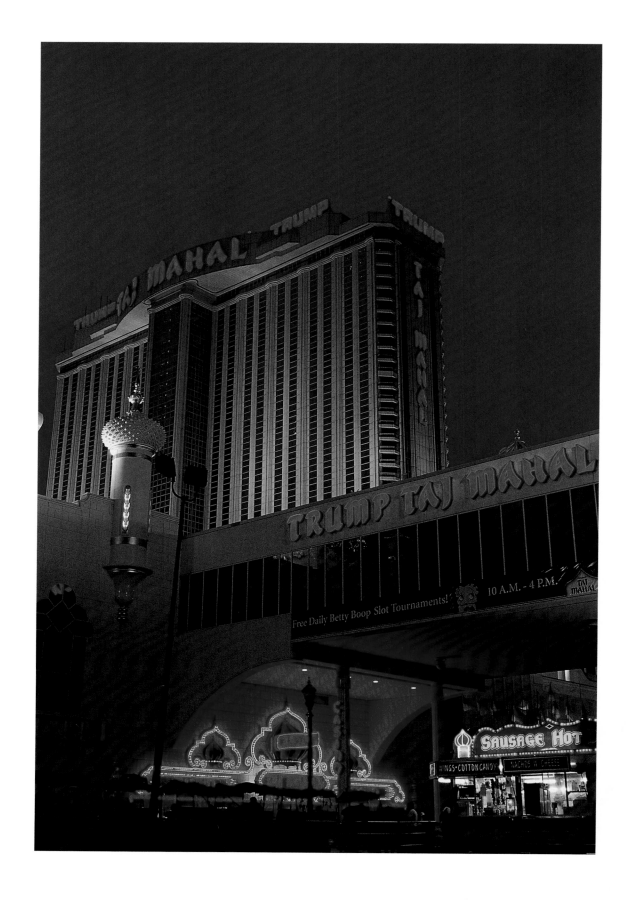

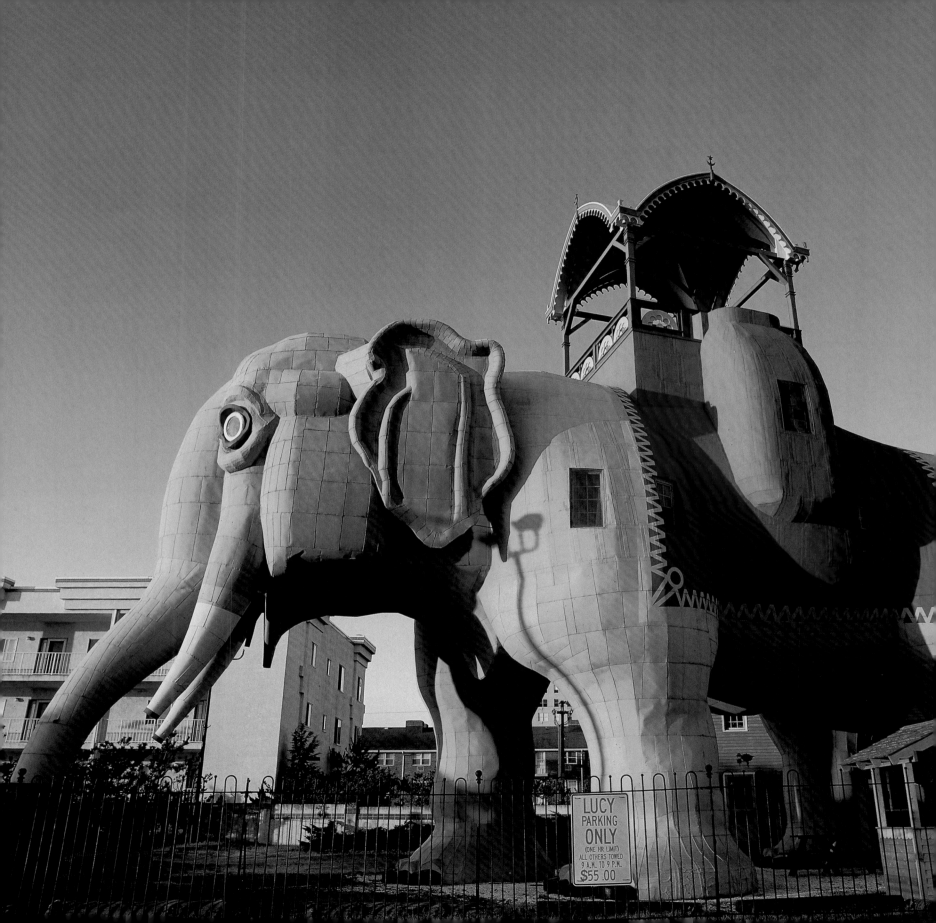

LUCY
PARKING
ONLY
(ONE HR LIMIT)
ALL OTHERS TOWED
9 A.M. TO 9 P.M.
$55.00

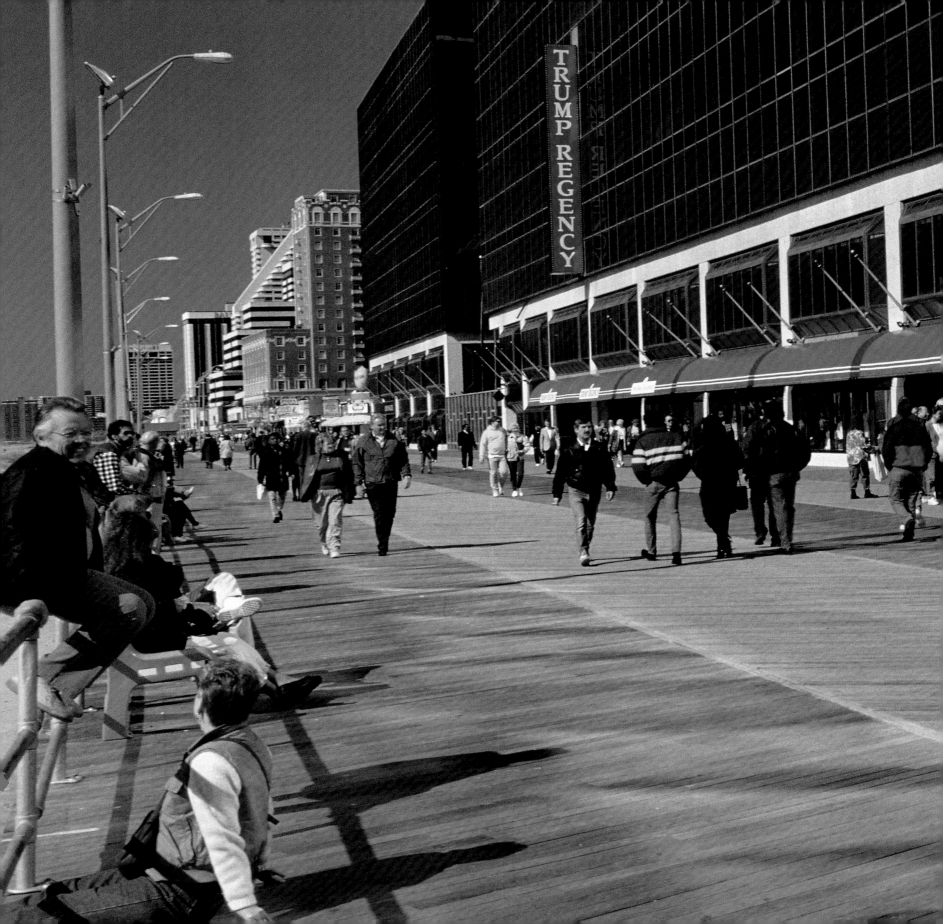

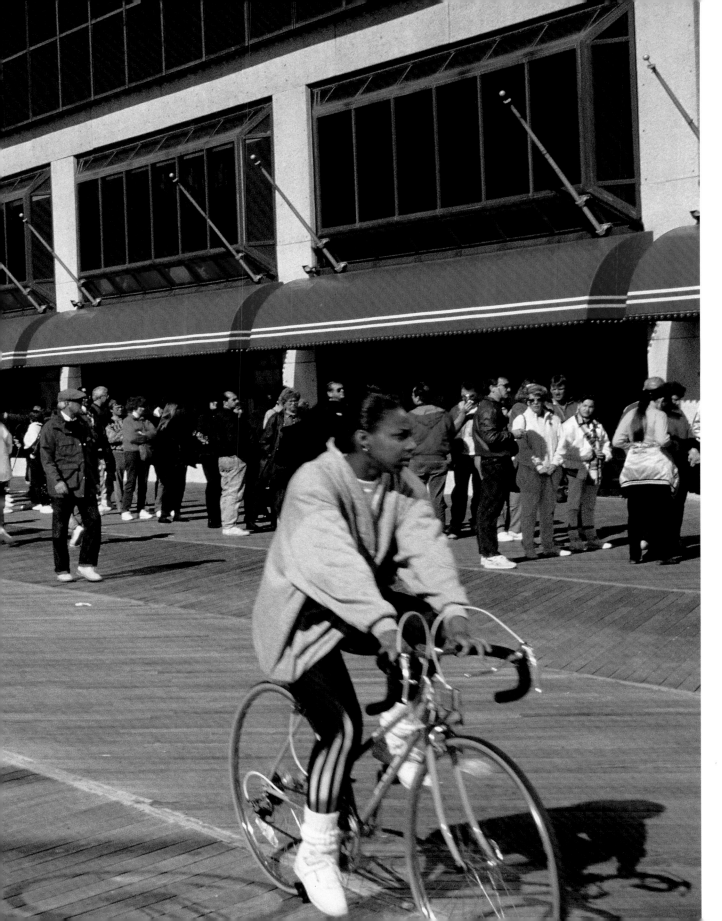

A six-mile boardwalk leads sightseers along Atlantic City's shore, past swimming areas and amusement piers. The community's first boardwalk was built in 1870. It not only allowed guests to promenade along the beach, but also solved the problem of sand in the lobbies of the local hotels.

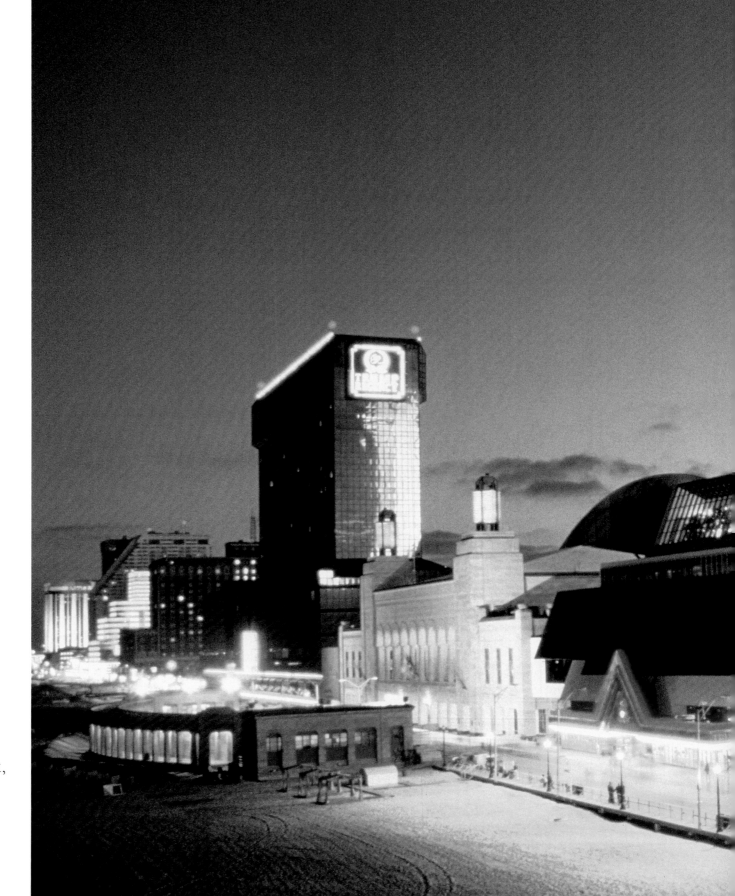

From the 1920s to the 1940s, Atlantic City was the destination of choice for Hollywood starlets, business magnates, and socialites. City leaders were constantly searching for glamorous new attractions; one of these was the first Miss America pageant, held here in 1921.

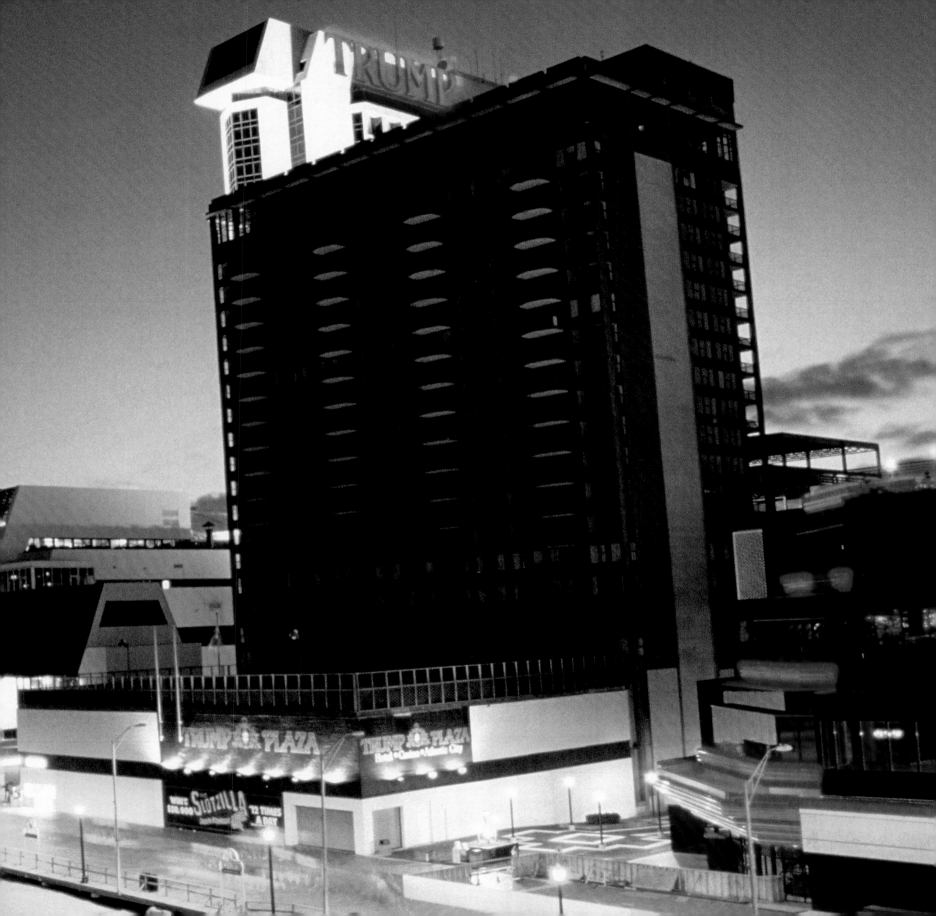

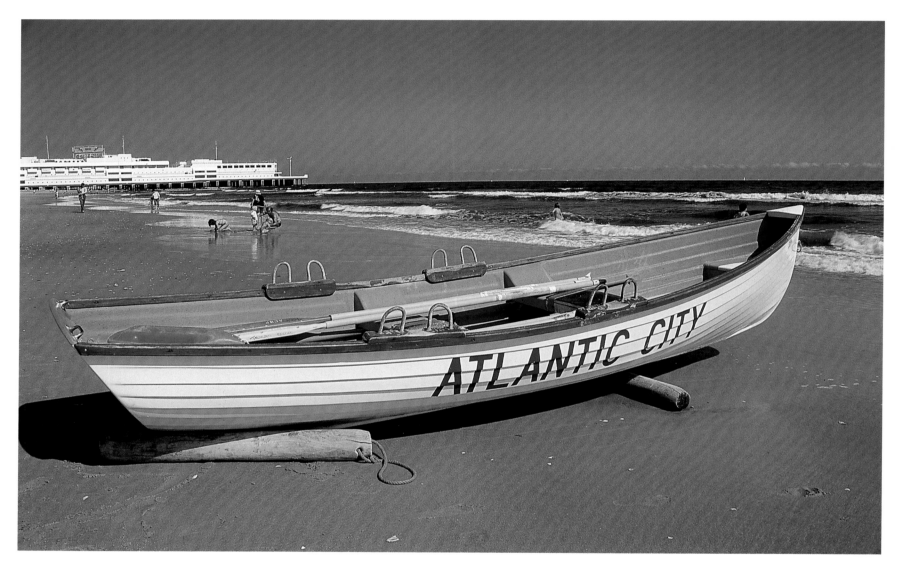

A lifeboat rests on a sparkling strip of beach near Atlantic City, on Absecon Island. The island hosts a number of annual competitions such as the Atlantic City Lifeguard Classic in July, which draws competing beach patrols from north and south along the coast.

The shores near Ocean City are the best of both worlds. There are secluded sand dunes where native grasses and animals remain undisturbed. Just a few steps away, a two-mile boardwalk offers white sand beach on one side and restaurants, shops, and amusement park rides on the other.

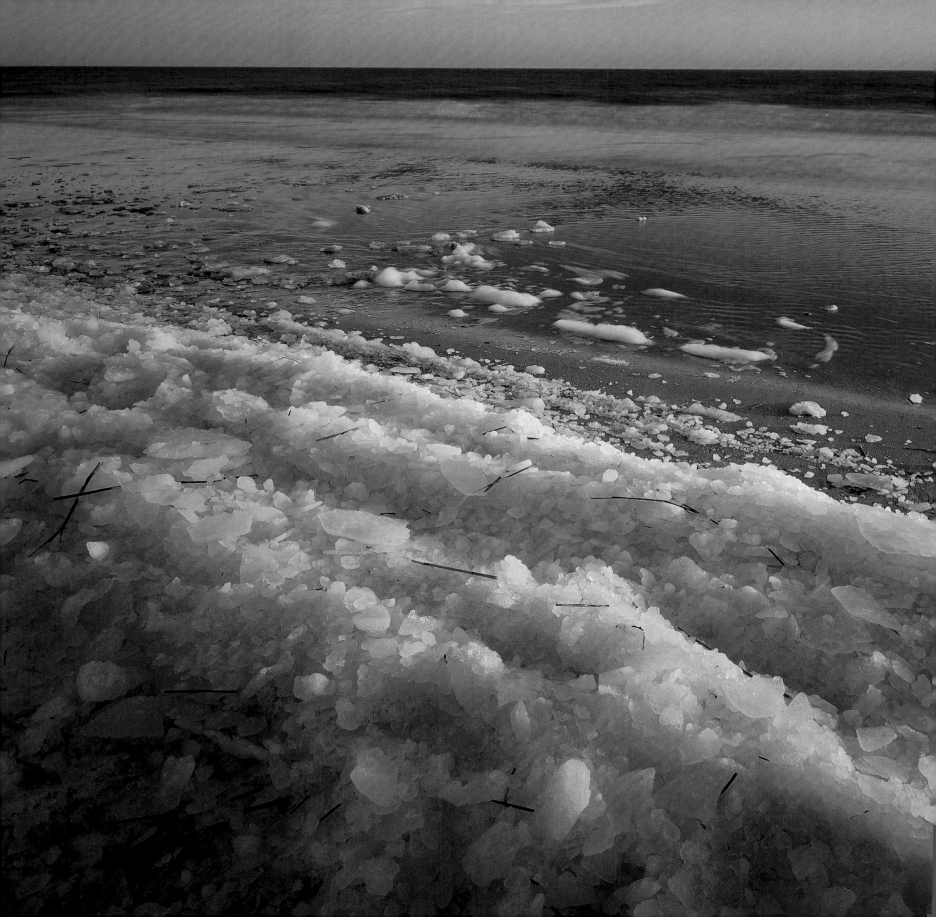

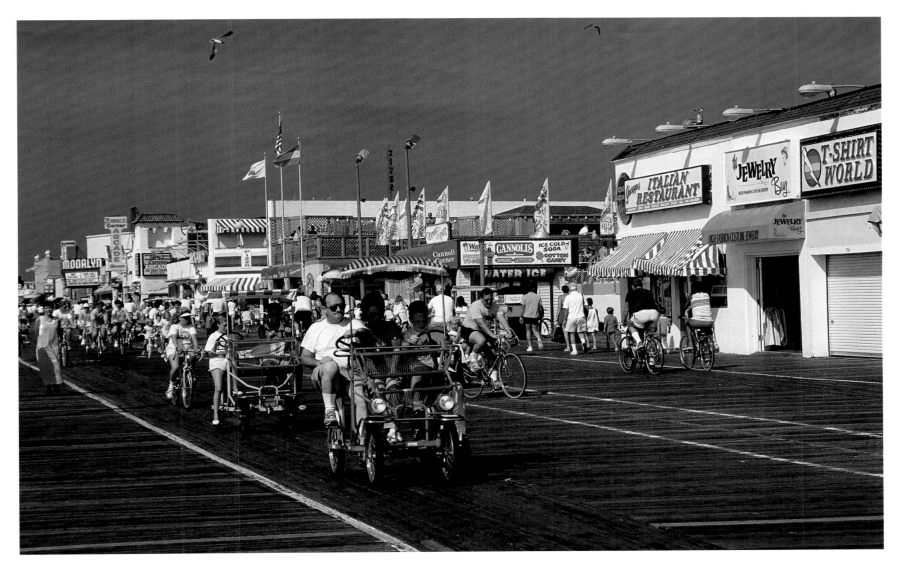

Like Ocean Grove to the north, Ocean City was founded as a religious retreat in the late 1800s and early 1900s. Many of the Victorian inns and homes built during this period still stand today.

Ice on the shoreline of Cape May State Park marks the end of the region's prime birding season. Enthusiasts flock to the park's beaches and wetlands in spring and fall, hoping to spot migrating songbirds as well as peregrine falcons, ospreys, and sharp-shinned hawks.

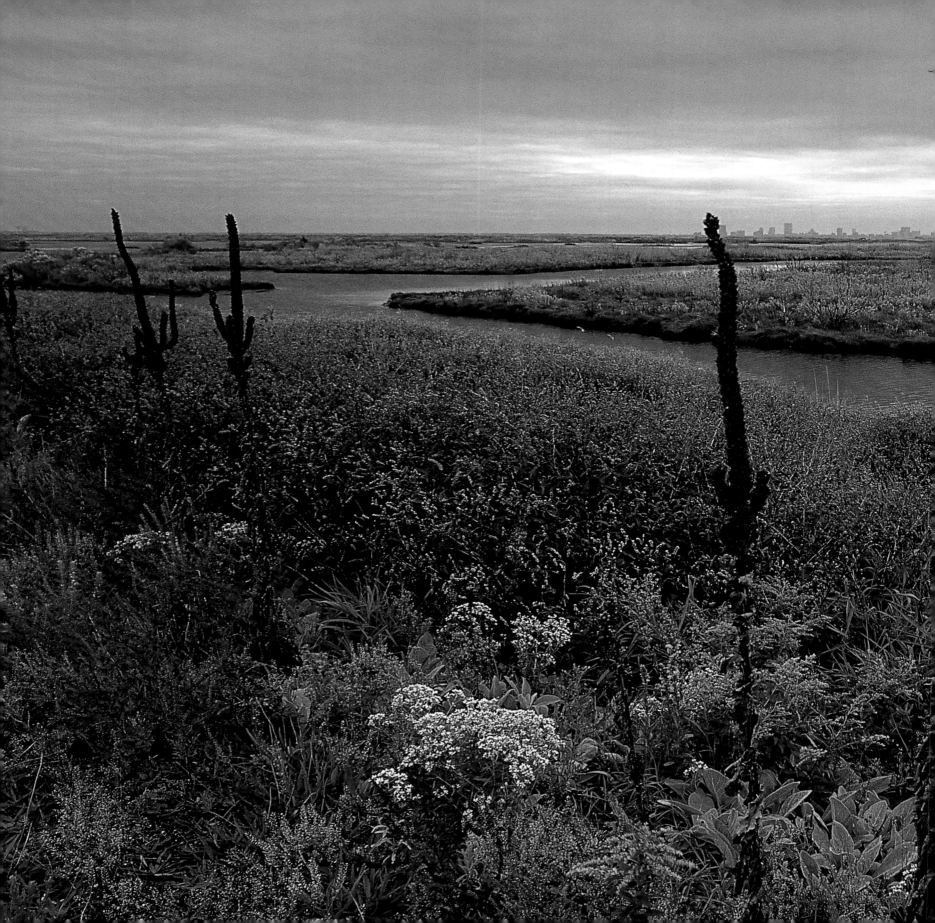

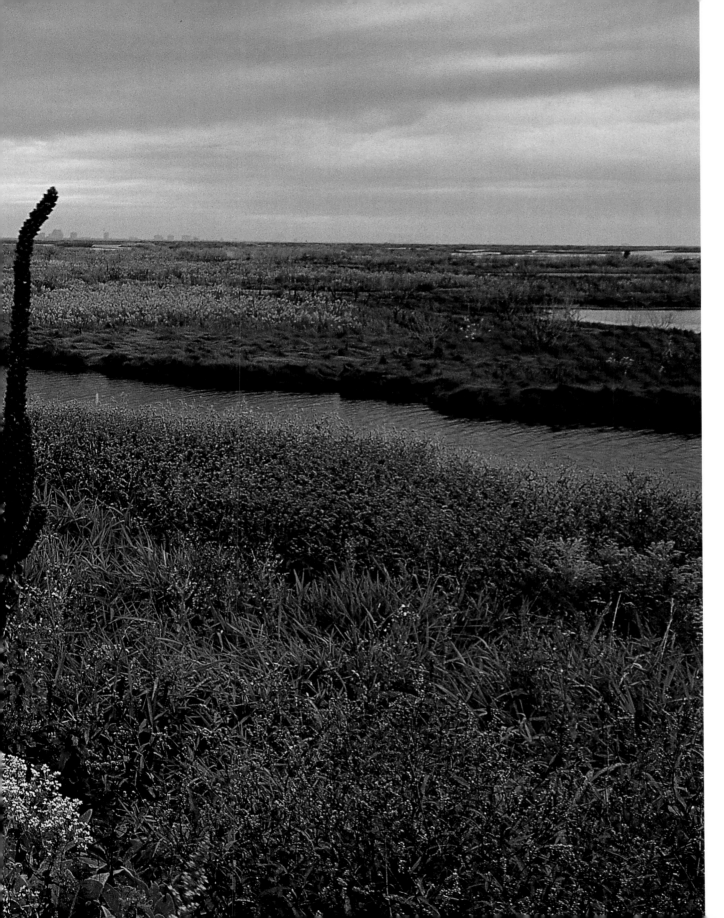

Although the glow of casino lights can be seen in the distance, the Brigantine Division of the Edwin B. Forsythe National Wildlife Refuge seems a world away from Atlantic City. Here, snow geese winter in the wetland reeds and thousands of migrating birds find temporary refuge along the Atlantic flyway. The preserve was established in 1939.

Hereford Inlet was a welcome refuge for early sailors along the coast, as they sought safety from the shifting sandbars and sudden storms of the Atlantic. The Hereford Inlet Lighthouse was built in 1874. More than a century later, sailors can still see the beacon from 14 miles off the shore.

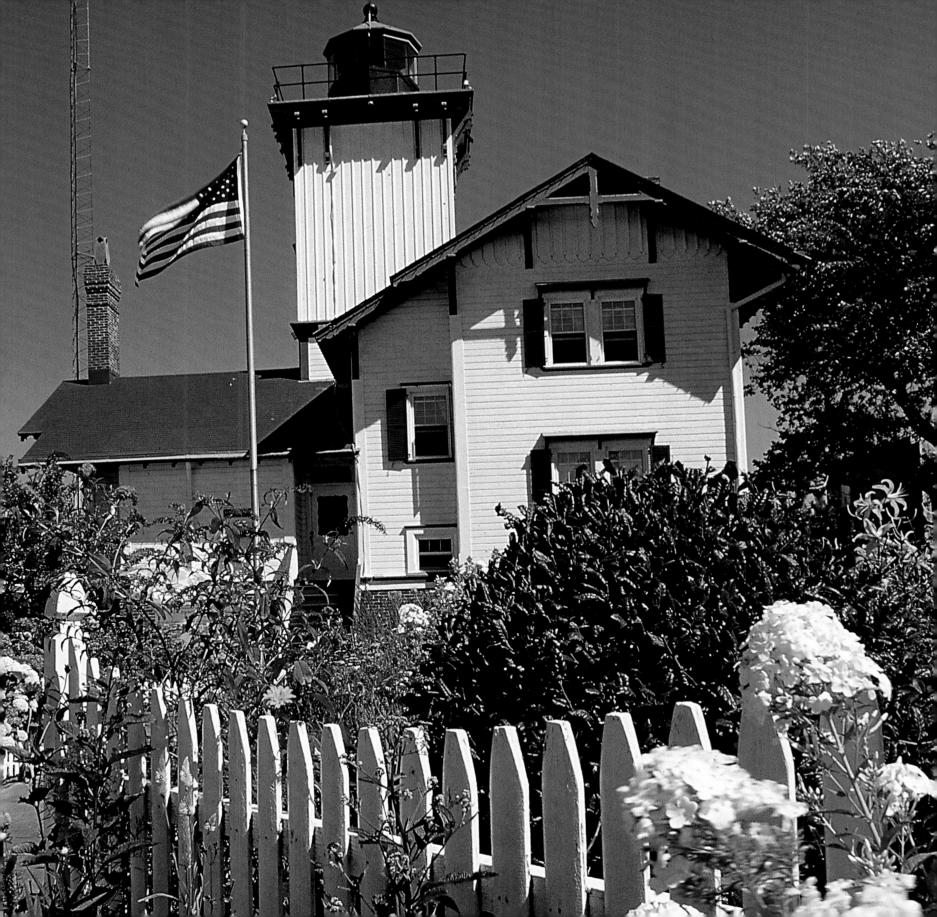

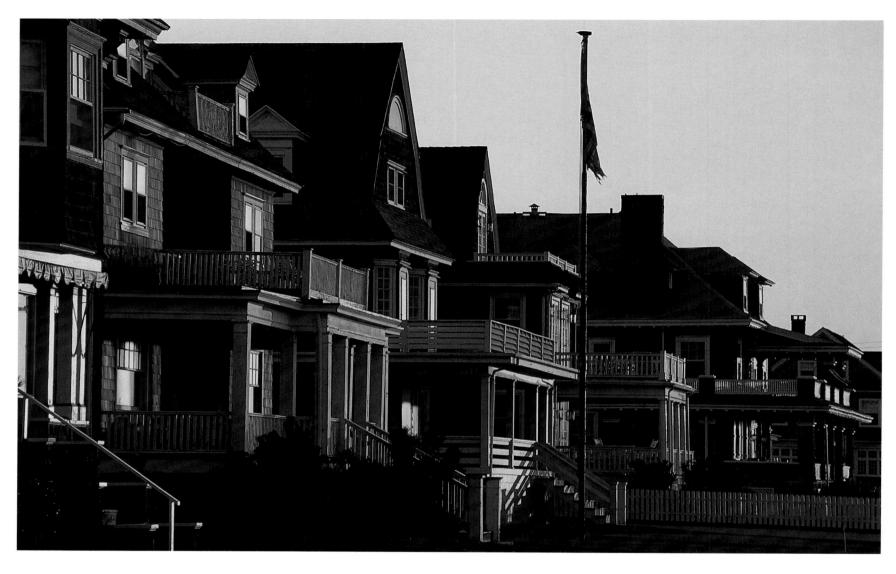

Sunseekers weren't the first to discover the riches of Cape May.
The Lenni-Lenape natives lived, fished, and hunted here before
the arrival of Henry Hudson in 1609. Colonists established the
area's first settlement in the 1630s.

Billed as America's oldest seashore resort, Cape May attracts thousands
of sightseers each year with its quaint streets and modern attractions.
Fishing charters, whale-watching expeditions, and sightseeing tours
cater to visitors.

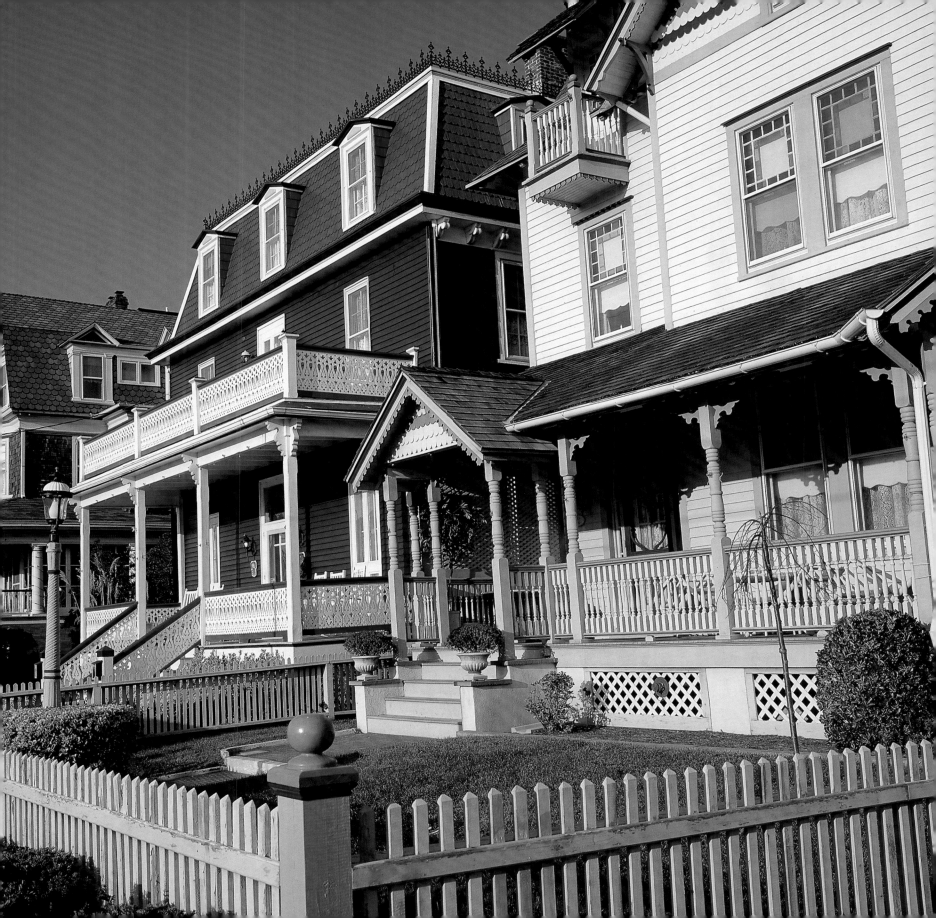

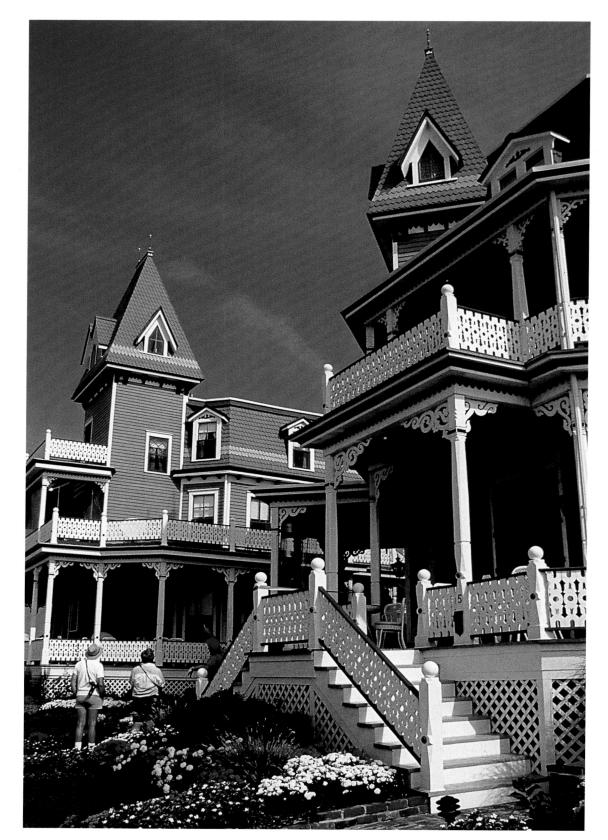

Fire tore through Cape May in 1878, destroying most of the city. Some business owners argued that this was an opportunity to build modern resorts. However, the community elected to keep its charming, cottage-era style, rebuilding homes and inns in imitation of the originals. More than 600 restored heritage buildings still stand.

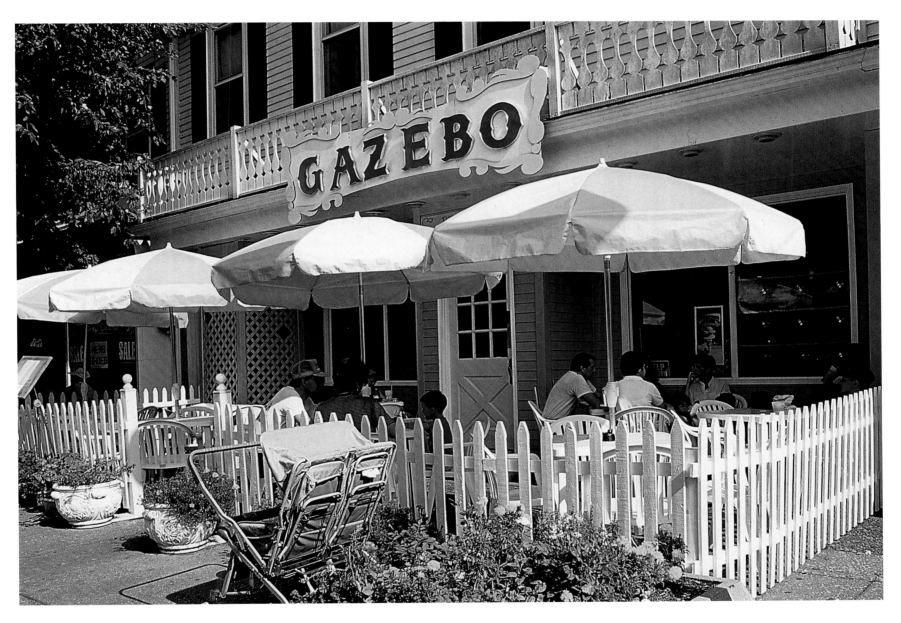

By the 1830s boarding houses and small inns were catering to wealthy summer visitors in Cape May. In the 1960s the community marketed plots of land to Philadelphia vacationers, and single-family cottages sprang up along the shore.

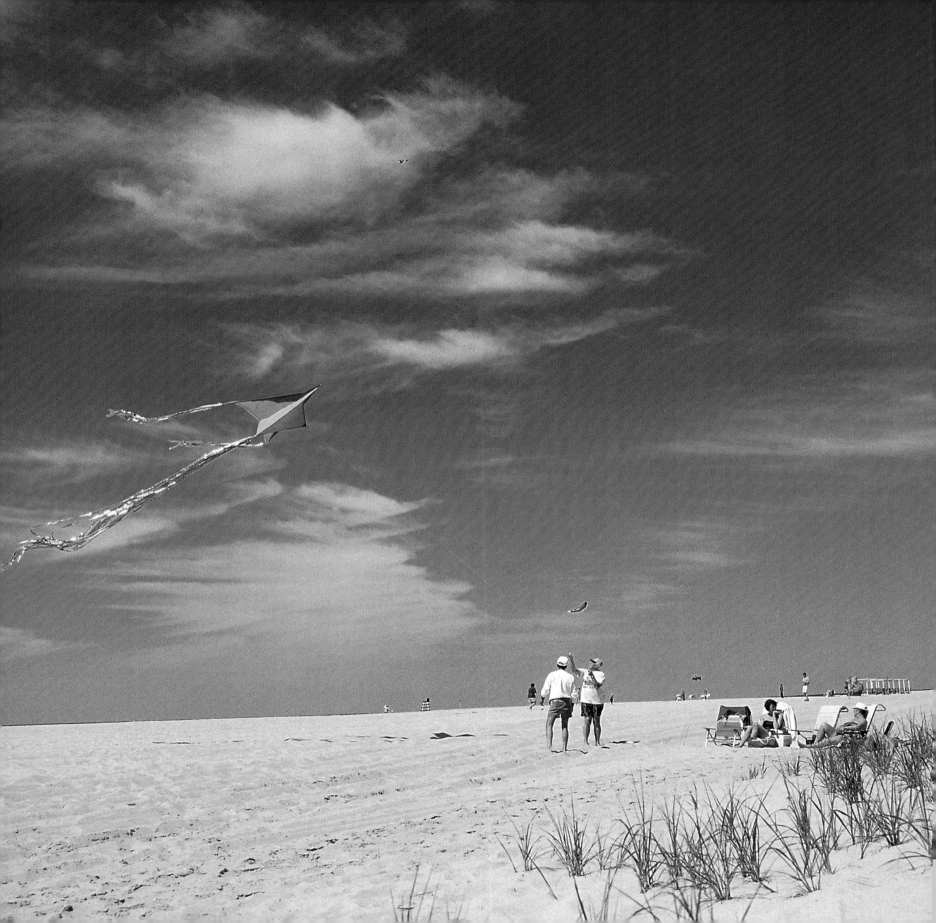

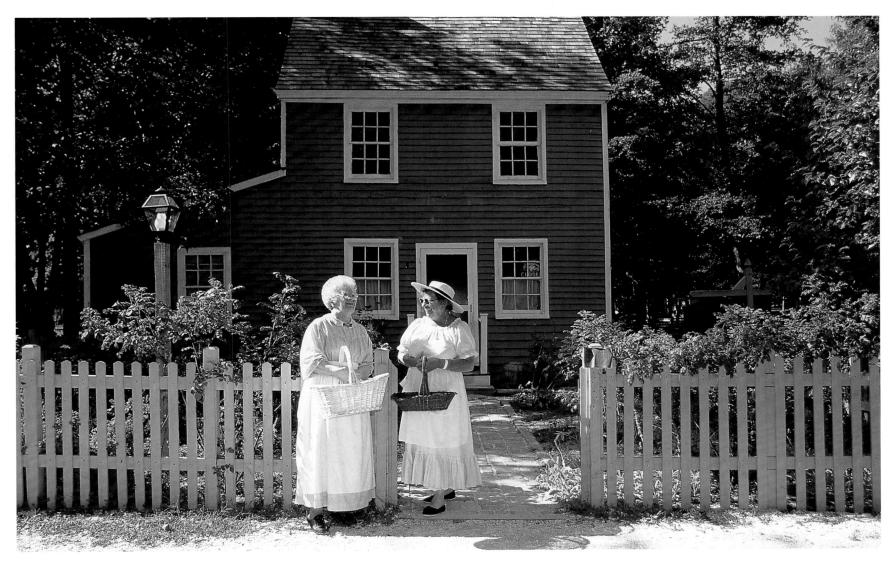

At Historic Cold Spring Village, visitors can wander through 20 restored buildings, brought here from sites throughout Cape May and Cumberland counties. Costumed staff bring the mid-1800s to life.

A coastal heritage route through southern New Jersey leads from the boardwalk of Ocean City, south past Tuckahoe, Dennisville, and Avalon, to Cape May. Cape May is one of five national historic landmark cities in America.

This white-tailed deer finds abundant forage in New Jersey's forests. About 15 million white-tailed deer roam North America, as far north as Canada's Great Slave Lake and as far south as Mexico. The deer are named for the white patches, or flags, on their tails, visible as they leap through the brush.

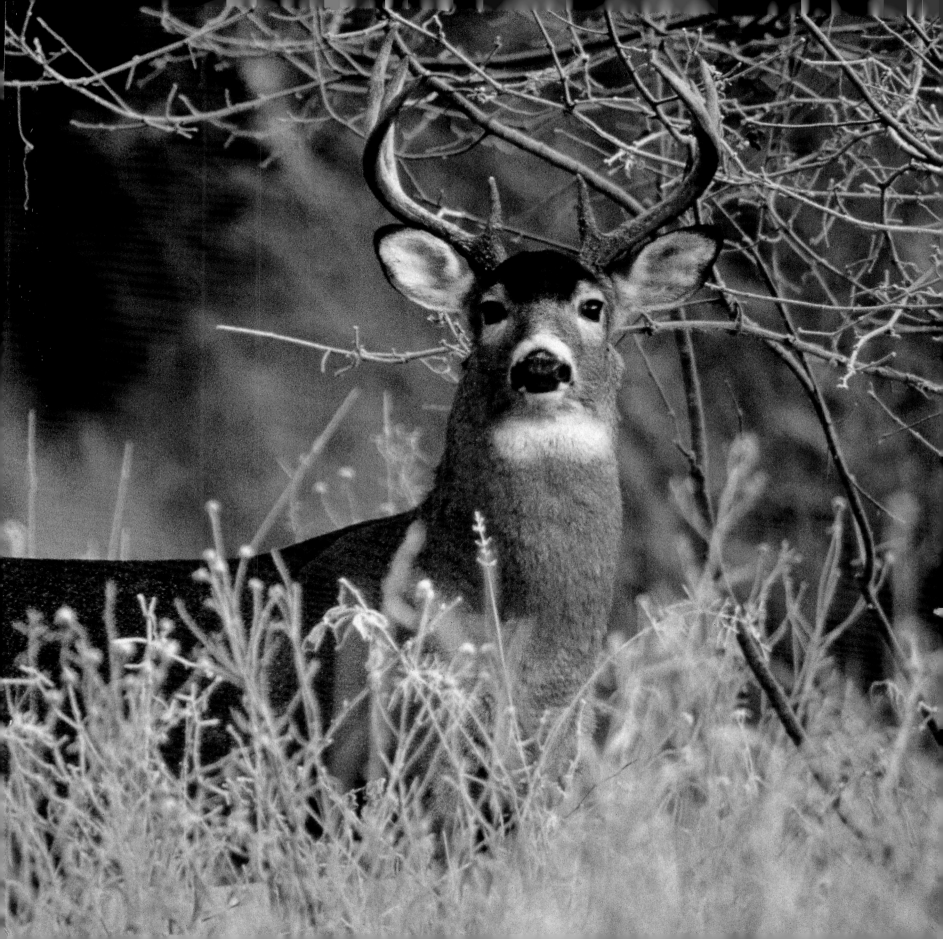

Photo Credits